ISBN 978-1-4400-8792-9
PIBN 10020766

1 MONTH OF
FREE
READING

at

www.ForgottenBooks.com

By purchasing this book you are eligible for one month membership to ForgottenBooks.com, giving you unlimited access to our entire collection of over 700,000 titles via our web site and mobile apps.

To claim your free month visit:

www.forgottenbooks.com/free20766

English
Français
Deutsche
Italiano
Español
Português

www.forgottenbooks.com

Mythology Photography **Fiction**
Fishing Christianity **Art** Cooking
Essays Buddhism Freemasonry
Medicine **Biology** Music **Ancient
Egypt** Evolution Carpentry Physics
Dance Geology **Mathematics** Fitness
Shakespeare **Folklore** Yoga Marketing
Confidence Immortality Biographies
Poetry **Psychology** Witchcraft
Electronics Chemistry History **Law**
Accounting **Philosophy** Anthropology
Alchemy Drama Quantum Mechanics
Atheism Sexual Health **Ancient History**
Entrepreneurship Languages Sport
Paleontology Needlework Islam
Metaphysics Investment Archaeology
Parenting Statistics Criminology
Motivational

A MANUAL

OF

OIL PAINTING.

BY

THE HON. JOHN COLLIER.

SECOND EDITION.

CASSELL & COMPANY, Limited:

LONDON, PARIS, NEW YORK & MELBOURNE.

1887.

A Manual of Oil Painting.

Part I.

PRACTICE.

THE art of painting in oils is a very difficult one, and not the least of its difficulties consists in the great uncertainty that exists as to the proper methods to be pursued. As a rule the great painters have been too much occupied with their painting to explain to the world how their effects have been produced. Indeed, it would seem that they have not always known themselves; for when they have theorised upon the subject their theories have been often quite irreconcilable with their practice.

Fortunately, they have generally had pupils who have carried on the tradition of their masters' work, and on the Continent this excellent system is still in force at the present day, for most of the great foreign painters think it their duty to give up a certain amount of their time to teaching, without any other reward than the additional fame conferred on them by the successes of their pupils.

For some reason or other this practice is almost unknown in England. Our English painters have no

B

pupils, so the experience they have so laboriously acquired for themselves is of no profit to others. It is true that the schools of the Royal Academy are visited in turn by some of the Academicians, but the utmost that a student can hope to gain from these visits is a confused jumble of at least a dozen different methods.

Nor is there much enlightenment to be gained from books. It is a melancholy fact that more non-sense can be talked about art than about any other subject, and writers of treatises on painting, from the great Leonardo downwards, have not been slow to avail themselves of this privilege. The student who attempts to model his practice on their precepts must inevitably arrive at the most disastrous results.

I am aware that after having said this it must seem the height of folly to add another to these treatises; but I have a firm conviction, in spite of all experience, that it is possible to apply ordinary common sense to these matters, and I mean to try to do so.

First of all it may be as well to lay down, with some attempt at precision, the object the student should have in view.

To whatever use he may mean to put his art eventually, the one thing that he has to learn *as a student* is how to represent faithfully any object that he has before him. The man who can do this is a painter, the man who cannot do it is not one. Of course there is more to be done in painting than this, but once this power has been attained the student

stage is at an end—the workman has learnt his craft, he has become a painter.

Of course, having got so far he may fail to apply his knowledge to any good purpose, but at least the means of expression are ready to his hand.

This representation of natural objects by means of pigments on a flat surface is a very definite matter, and most people are competent to judge of the truth or falsehood of such a representation, if they are fairly put in a position to do so ; even the student himself can be a good judge of the success of his own work if he will make due allowance for his natural partiality for it.

There is, after all, nothing so very mysterious in the matter. Every natural object appears to us as a sort of pattern of different shades and colours. The task of the artist is so to arrange his shades and colours on his canvas that a similar pattern is produced. If this be well done the effect on the eye will be almost identical. As far as seeing is concerned, the two things, the object and the picture, will be alike ; they will be absolutely different to the sense of touch, or indeed to any other sense, but to the sense of sight they will be practically identical.

I am sorry to say anything that may diminish the awe with which the outside public regards my profession, but instead of finding it (as many worthy persons do) almost miraculous that a perfect representation should be made on a flat surface of solid objects, I have always wondered why it should be so difficult.

B 2

Let us state the problem once again—

Whenever we look at a scene we have a patch-work of shades and colours floating before our eyes, and this in fact *is* the scene ; we have to place on canvas similar patches, similar in form, position, colour, and intensity. It ought not to be difficult ; any one who can judge if two colours and two forms are alike ought to be able to paint an accurate picture of anything that he has before him. And yet it undoubtedly is difficult—so difficult that a long and laborious course of study is needed before even the most gifted can achieve a real proficiency in this elementary part of their art.

Unfortunately, in England at the present day, a student is left very much to his own resources when he enters upon that most difficult part of his studies which comprises the practice of painting as dis-tinguished from that of drawing. In most of the art schools now in existence it is easy to get good in-struction in drawing, but the teaching of painting is mostly very inadequate. The painter who knows his business will not, with some few exceptions, waste his time in giving instruction, and the instruction to be gained from a painter who does not know his business is worse than useless.

If by any means the student can obtain personal instruction from a competent painter he will not need this handbook nor any other ; but if he cannot I will endeavour to show how he may, to a great extent, teach himself.

In the first place, it is necessary to have some sort

of method, both as to the routine of study and as to the technical processes to be employed. With regard to technique, I shall describe a very simple system of painting which I recommend the student to try ; but as it frequently happens that a method which suits one man does not suit another, I shall give a short account of some other methods, in the hope that amongst them the student will find the one that is best suited to his talent.

And first as to the routine of study. I start by supposing that the student has already acquired a fair knowledge of drawing ; there is no lack of good teaching of drawing in England, so there is no excuse for incompetence in this matter.

By good drawing I mean a power of accurately portraying the shapes and position of things, but it is not at all necessary to have any special dexterity with the pencil. In oil painting the original drawing may be clumsy, untidy, vacillating—in short, have every possible fault of execution ; but as long as it is sub-stantially accurate it will serve its purpose. Of course, there is no advantage in clumsiness ; it simply does not matter. There is one general principle which I think may be of service in drawing. The painter should always train himself to seize first on the more important points of the object he is depict-ing, and then go on to the less important points in turn.

First of all, he should fix the position of the object he is drawing with regard to the other objects in the picture, then he should determine its relative

size, then its shape, then the proportions of its parts, and finally its minute details.

In the case of a student who is able to make a fairly accurate—if somewhat bungling—drawing, the course of study I should recommend is this: he should begin by what is called "still life;" that is, he should carefully make an arrangement of some simple objects which are not liable to any change in appearance; it matters very little what they are as long as they conform to this rule, which, of course, excludes all living things. Perhaps china and pots and pans make the best preliminary exercises, care being taken to avoid any elaborate patterns, or anything in which the detail is intricate. These objects should be arranged with some simple background behind them, and in as steady a light as possible—that is, a light that remains practically the same from day to day, and from hour to hour. A room with a north window is best; if there are other windows in the room, they can be blocked up. Should there be no convenient room with a north window in it, some room can always be found in which the light is steady for a part of the day, and the painting should only be done during this part of the day. Even with a north window a great deal of inconvenience can arise if there be any building in front of it which can reflect the sunlight; this should be carefully taken into consideration in choosing the painting room. Of course, it is better in every way to have a regular studio; but it is not every beginner who can indulge in such a luxury, whereas a room in

which it is possible to paint can be found in every house. There is one other thing to be considered in the choice of a room : it must not be too small. It is essential that the painter should be able to see his work from a good distance. The kind of window matters very little as long as the light is steady. The window can be high or low, big or small ; a light from above is in some ways best, but it can very well be dispensed with ; and a very small window gives light enough to paint by if the painting be brought close enough to it.

The way in which the object is lit up is comparatively unimportant as long as the lighting remains the same. Any kind of light and shade is good for study, but it is very important that there should be a good light on the picture. If an oil picture be turned towards the light it gets what is called a shine—that is, it reflects the window. Of course, if it be too much turned away it does not have light enough on it, so it must be turned sideways with regard to the window, unless, indeed, the light comes very much from above, in which case it can be placed in almost any position —which is one of the advantages of a top light.

It is, therefore, the lighting of the picture that has to be chiefly considered in arranging the position of the " still life." I shall point out, later on, how important it is that the picture should be often placed side by side with the object, and then looked at from some distance ; consequently, the object should be so arranged that when this is done the picture receives a good light.

And now a word as to the materials to be used.
A stretched canvas is on the whole the most con-
venient thing to paint on ; it should neither be very
rough nor very smooth, nor should it be of too small
a size ; about 24 × 20 inches is a good size for studies.
On canvases much smaller than this the work is apt
to be niggling, but they may be as much larger as the
ambition of the painter may suggest. In many ways
it is better that the study should be of the same size
as the object, but it is not essential. The painter
should always, if possible, stand up to his work ; so
the easel must be tall and substantial. As it is im-
portant that the picture should be perpendicular, the
common three-legged easels which slope backwards
should be avoided. It is also important that the
picture should be readily moved up and down, so that
any part which is being worked at may be kept at a
level with the eye. The "still life," also, should be
placed more or less on a level with the eye.

The preliminary drawing should be made with
charcoal. There is no other material that gives such
freedom of execution and such facility of correction.

To begin the drawing, the easel should be placed
at some distance from the object, and the draughts-
man should stand as far from his canvas as is con-
sistent with the power of drawing on it. He should
practise drawing with an outstretched arm, and every
now and then should step backwards to judge better
of the effect. Indeed, there is no more useful general
rule in painting than this : that the painter should con-
tinually look at his picture from as far off as possible.

From time to time the picture should be placed side by side with the object, so that they can be looked at together from the end of the room. This is supposing the picture to be of the size of life; if it be under life-size it should be placed at that point in front of the object where they both appear of the same size when looked at from the end of the room. When the two, picture and object, are thus seen side by side, it must be a very dull eye that cannot distinguish inaccuracies.

This is the most potent aid to self-improvement; by continually resorting to this method the student can be his own teacher, and correct his own faults. It should be employed from time to time throughout the whole progress of the painting. Indeed, it is quite possible to leave the canvas permanently side by side with the object, and to walk backwards and forwards from the end of the room during the whole course of the painting, giving a touch or two at a time, and always going back to see if it be right. This method is much less tedious than it seems; and that it is capable of giving good results is abun dantly proved by the fact that Sir John Millais never paints in any other way. So if any student like to take it up he can be sure that it will not be the fault of his method if he fail to take the highest rank in his profession. Nevertheless, I think the modification of it that I suggest will be found more generally convenient; that is, that the painter should habitually work a good way off from the object, but should from time to time place his picture side by side with it,

and then look at them both together from a dis-
tance.

As a further aid in detecting inaccuracies a look
ing-glass is invaluable. A large upright one should
be kept in the painting room, in such a position that
both the picture and the object can be seen in it at
the same time.

The special usefulness of a looking-glass consists
in this, that the most difficult errors to detect are
those which come under the head of obliquity—that
is, there is a continual tendency to draw things a little
askew ; but when such drawings are seen in the glass
the obliquity is precisely reversed, and strikes the
eye the more forcibly the more it has become ac-
customed to it. For instance, the painter in drawing
a line which should be perpendicular has made it
incline (let us say) a little to the left. If the error be
not noticed at once the eye soon gets accustomed to
it, and takes all lines inclining a little to the left as
perpendicular. But in the looking-glass this very line
appears inclining to the right, and consequently seems
even more out of the perpendicular than it really is.

Quite apart from this, the advantage of having a
fresh view of one's picture such as the looking-glass
gives cannot be over-estimated. In painting, as in
everything else, there is a fatal tendency to become
accustomed to one's faults. There is nothing like
seeing them from a different point of view to give
renewed freshness to one's pictorial conscience.

Of course the first thing in making a drawing is
to get the more important lines right in shape and

position. In order to do this with more precision it is sometimes recommended that the drawing should be blocked out, as it is called—that is, that it should all be drawn in straight lines, curved portions and all, and the curves eventually obtained by rounding off the angles.

I think myself it is a mistake to draw things so very differently from how one sees them. A curve should be drawn as a curve from the very beginning; but, of course, the minor details should be left till the last. The first sketch should be a bold rendering of the principal lines, giving the general curvature but neglecting any minor sinuosities. This should be corrected until all the proportions and positions are right. The lines should then be half rubbed out and carefully re-drawn, the minor sinuosities being put in, and the whole line thoroughly studied with regard to its sweep and curvature. Any straight lines may as well be ruled; we should never disdain any aid to accuracy. Wherever it is possible, actual measure- ment should be used—that is, generally for every line that is not foreshortened. Even foreshortened lines may be roughly measured on a pencil held in front of the eye, and then compared with other lines that are not foreshortened. A plumb-line is occasion- ally useful for determining what lines are perpen- dicular, and what part of the object comes over other parts. But, as a rule, these latter aids will scarcely be found necessary if the student avail himself of the accuracy to be gained by placing the canvas side by side with the object.

When the main lines have been accurately drawn in this. manner, the charcoal should again be half brushed off (either with a soft feather-brush or by flipping the canvas), and the lines should then be carefully re-traced with brown or black paint, made fluid with turpentine, the lines being made fairly thick and not too faint.

The picture is now ready for painting on. Of course it is very important to have a proper assortment of colours, in the choice of which three things have to be borne in mind :—

Firstly, the colours must be permanent. It is true that it matters very little whether the student's earlier efforts be painted with permanent pigments or not ; but every student hopes to turn out valuable work some day, and should consequently get into the habit from the very first of using none but trustworthy pigments.

Secondly, the colours must be capable, with careful mixing, of rendering all, or nearly all, the tints to be met with in Nature.

Thirdly, they must be as few in number as is consistent with the foregoing consideration ; for it is obvious that the fewer they are the easier it is to get thoroughly at home with their various combinations.

I think the palette I shall now recommend fairly meets these three requirements—Brown ochre, yellow ochre, Naples yellow, flake white, orange vermilion, light red, Chinese vermilion, rose madder, burnt sienna, cobalt, ivory black.

These colours will be found sufficient for ordinary purposes; but there are certain greens, especially those occurring in landscape, which require another yellow, and the choice of this is of some difficulty. Chrome is precisely the tint that is wanted, but its stability is too doubtful to allow it to be recommended.

Pale cadmium will fairly take its place, and is said by the chemists to be quite safe. A still paler cadmium, called mutrie yellow, is much more the tint that is required; but it is certainly unsafe, and should be resolutely avoided.

There are three other colours which should be held in reserve, to be used occasionally when required. Emerald oxide of chromium is a very powerful and perfectly permanent green, which will be found useful as giving a richer and deeper tint than any combination of cobalt and yellow. Personally I find it useful in flesh-tints, but for these there is certainly no necessity for using it.

So far, my palette has the great recommendation of being the one used by Mr. Alma Tadema, from whom I have taken it; but there are two other colours which he uses very little, if at all, which I think, nevertheless, the student may find useful at times. These are raw umber and deep cadmium. Although a tint can be mixed of other colours which shall fairly represent raw umber, yet it is so convenient in the making of certain browns and greys that I should be sorry to do without it. Deep cadmium is so fine a colour, that it would

be a pity not to have it at hand when a particularly brilliant yellow is required.

Equipped with these colours, the student may feel confident that there is hardly a tint in Nature that he cannot reproduce, with some inevitable loss of brilliancy at times, but still with substantial accuracy. There is no reason why he should not occasionally experiment with other pigments that are known to be permanent; but it will save him a great deal of time, and probably much disappointment, to put off these experiments until he has advanced some way in his art. I am quite certain that my list is good enough to begin with at any rate.

I have put the colours in the order in which I set them on the palette. It is an order which I have found convenient in practice, but, of course, their relative position matters very little; but it is as well to fix on a given arrangement, and not alter it, as then the operation of dipping the brush into any particular colour is much more rapid and certain.

The choice of the palette itself is not of much importance. It should be rather large than small, but not so large as to be tiring to hold.

Some kind of medium must be used with the colours, and the choice of it is rather difficult. I think on the whole a mixture of copal, linseed-oil, and turpentine, is the best for general purposes. It should be mixed in about equal proportions of all three, unless the picture be required to dry quickly, when the linseed oil should be diminished, or even

left out altogether. The medium should be held in a dipper fastened on to the palette.

The brushes should be numerous and varied. The most generally useful are flat hog's-hair brushes, which should range in size from about an inch in diameter to about a quarter of an inch. There should be at least two fine sables, and two so-called writer-brushes, for drawing lines; these last should always be used in retracing the charcoal outline. One or two round hog's-hair will also be found useful.

For the first day's painting only the larger brushes will be necessary. A palette-knife is quite indispensable; it should be of horn, as the contact with a steel palette-knife is supposed to affect the permanence of some pigments.

Economy should be studiously avoided in the setting of the palette; there is nothing more likely to give a bad style in oil painting than insufficiency of colours. In this, but in nothing else, the painter should be reckless. He should also be warned against endeavouring to paint with the half-dry remains of colour that accumulate on the palette. Some pigments, such as rose madder, remain in a fit state to paint with after having been on the palette for many days; but others become sticky in a day or two. As soon as they are in this state they should be thrown away. Colours can be kept moist for some time by putting them in water, but as a rule it is not worth while to do this.

A considerable economy can, however, be practised in brushes by always cleaning them oneself. A

paint brush will last a long time if it be carefully washed soon after it has been used. The best way of washing them is to put a little soft soap in the palm of the hand and to work the brushes about in this, rinsing them out in moderately warm water from time to time. When they are free from all traces of colour, they should be well rinsed in cold water, so as to get rid of the soap, then squeezed out with a cloth, and any straggling hairs brought together, so as to preserve the proper shape of the brush, and then put in a moderately warm place to dry.

We will now suppose that the palette is set. How shall we proceed to paint with it?

The first thing to be done is to match the tints of the object, and to put them on the canvas in their proper places without the slightest attempt at detail or execution ; and the easiest way to do this is to take the palette-knife, mix—to the best of one's judgment —a tint corresponding to some patch of colour on the object, and then hold up the palette-knife in front of this patch of colour and compare the two. When the comparison is put in such a direct manner to the eye no very bad match can pass muster. The first shot will probably be ludicrously unlike, and the mixture must be modified again and again until complete success is arrived at, which is only the case when the end of the palette-knife can hardly be distinguished from the patch of colour in front of which it is held. The paint should then be dabbed on to the proper place on the canvas, and spread with a brush until it is of the proper size and shape, care being taken

that the colour be sufficiently thick to prevent the
canvas showing through. This operation should be
repeated for every considerable patch of colour or
light and shade in the object or in the background
until the canvas is completely covered, when it should
look like a sort of mosaic, giving, when seen at some
distance, a good idea of the general look of the object
without any of its details. It is an operation of great
tediousness, but it should be strenuously persevered
with, as there is no other method by which a beginner
can hope to give anything like a really accurate re-
production of the tints of a natural object.

Besides being tedious, the operation has certain
difficulties which can only be overcome by the
exercise of considerable care. It will be found at
once that the tint on the palette-knife varies very
much according as it is turned towards the light
or away from it. To make the results uniform the
canvas should first of all be placed in a fairly strong
light, but sufficiently turned away from the window to
prevent any shine from appearing on its surface when
painted on. (This must be made the subject of direct
experiment: a dab or two of paint will settle the
matter). The palette-knife should then be held close
to the picture, with its surface parallel to the surface
of the picture; if the colours be matched with the
knife in this position they will look the same when
they are placed on the canvas as they did whilst being
matched. It is obvious that if this be not the case
the matching can only give false results.

When the canvas is covered in this way the first

day's painting is at an end. Care should be taken not to leave the paint too rough on any part. (When the learner is more advanced he may try laying on the paint roughly when a rough texture is needed, and smoothly when the surfaces represented are smooth ; but for the present he had better eschew these subtleties). Nor should any sharp edges be left ; they would probably have to be corrected, if ever so slightly, in the finishing, and an edge of oil paint is a troublesome thing to alter; consequently all the outlines should be a little blurred, as it is very easy to make them sharp at any time, and this should be done once and for all, wherever necessary, in the finishing.

I have mentioned that the paint should nowhere be so thin that the canvas can in any way show through. The reason for this is that the colour will be altered by the ground underneath, unless this ground be completely hidden ; it is only by putting them on thickly that we can trust our matched tints to be correct. The modifications that come from colour underneath showing through a thin coat of oil-paint are very curious, but I must defer the discussion of them. For the present it will be sufficient to say that a colour laid thinly on a dark ground appears colder—*i.e.*, bluer—than its natural hue, whereas a thin coat of colour on a light ground (such as an ordinary white canvas) assumes a warmer—*i.e.*, a more orange hue.

When the day's painting is over the canvas should be put in the sun, or in front of a fire, to dry, care being taken not to put it so close to the fire as to

make the oil bubble up. There will be no danger of this at a distance of from four to five feet from even a very strong fire.

Even when we have done our best to hasten the drying of our picture, it will certainly not be in a fit state to work on again until a clear day has elapsed. This is one of the serious inconveniences of oil painting ; but it can be easily met by having two pictures going on on alternate days, which is not a bad thing in other ways, as the change of subject gives the eye a rest.

When it is absolutely necessary to go on with the same painting day after day, the only plan to adopt is to paint a bit of it at a time ; but this is certainly not a good method for beginners. As a general rule, one should never touch an oil painting unless it is quite wet or quite dry. Unless very exceptional effects are required, there is nothing more fatal than to work at a picture when it is sticky.

In damp weather pictures are apt to be very slow in drying. This can be prevented, to a certain extent, by diminishing the proportion of oil in the medium.

When our picture is quite dry we must consider how to advance it a stage further.

In the first place it should be rubbed over lightly with linseed-oil ; it will very likely be found that in places, at least, the oil will not " take," as it is called— that is, it persists in congregating in little patches and leaving other patches quite bare. This can be remedied by breathing on the picture, when the oil will be found to flow quite evenly over it. The oil

C 2

should now be carefully wiped off again with a soft brush, and the picture will be ready for painting on.

It should first of all be placed side by side with the object, and looked at from the end of the room, and in the looking-glass. If there be much wrong with any of the tints it will be detected at once when looked at in this way, especially as the painter comes to it with a fresh eye. The picture should be left side by side with the object, and the tones corrected wherever necessary; the paint being now used quite thinly, and put on with the brush. The painter should always judge of the effect from the end of the room, and should, from time to time, resort to the looking-glass as a means of further refreshing his judgment. When the general tones appear quite right the picture should be brought away from the object, and the larger details should be put in, the forms being carefully drawn with any brush that seems appropriate— the rule, however, being observed that a small brush should not be used wherever a larger one can render the form *equally well.*

Texture should be given when necessary by dabbing the paint on roughly where uneven surfaces occur ; but, except in these places, the paint should be used thinly, so as to merely modify the first painting without entirely obscuring it.

The subsequent paintings should all be in this style ; finer and finer details being added, and especially towards the last the edges should be very carefully seen to ; texture always appears most at the edges, and can only be thoroughly rendered by a

very careful attention to their character. Wherever an edge appears quite sharp this should be given by an actual edge of paint, but it is most important that no edge should be painted sharply which is not quite sharp in Nature ; draperies have hardly ever quite sharp edges, but, of course, the degrees of sharpness and smoothness vary indefinitely, and all these degrees should be carefully rendered. Again, even a sharp edge is generally lost sight of somewhere or other, owing to its being of almost the same tone as some object behind it. To this also great attention should be paid. There is a curious tendency in the human mind to imagine it sees a continuation of any line when it knows that the object is continuous, and this is a tendency against which the artist should be particularly on his guard.

During the progress of these successive paintings the study ought to be gradually getting more like the object, until at last, when placed side by side with the object, and looked at from the end of the room, it ought, at first sight, to be almost doubtful which is which. Even for a beginner, if he follow this method it is quite possible to produce a picture which shall be astonishingly like any simple object, and, indeed, he must persevere until it *is* like the object ; for if it look markedly unlike it in any particular he ought to be able to see where the discrepancy lies, and to correct it accordingly.

The study should be regarded as finished when it looks so from the end of the room. If the room be of large size this is compatible with considerable breadth

of treatment. It is a pity for the student to bother himself with elaborate detail, which he can only see when close to the object ; for there is no difficulty in painting detail, the real difficulty lies in getting the general truth of tone and tint.

And here it may be as well to define our terms a little more precisely. Not only do natural objects vary in hue, but also in degrees of light and shade, and it is well to carefully distinguish between these two kinds of variations. For instance, two objects can be of the same darkness, but of different colours ; or they can be of the same colour, but of different degrees of darkness. Unfortunately, the terms gene rally used to express these variations are rather am biguous; but there is sufficient authority to justify me in using " tone " to express light and shade, and " tint " to express colour or hue. For instance, I should say of an object of a dark but strong red that it was low (or dark) in tone, but rich (or strong) in tint. At any rate, I propose to restrict the terms to these definite meanings for the remainder of this work.

Of the two, undoubtedly, truth of tone is the more difficult of attainment, especially to a beginner, and this for a very curious reason. The light and shade of objects are accidental peculiarities, and subject to continual variations, whereas their colours are mostly permanent, or, at any rate, only liable to small varia- tions on account of difference of illumination. So in thinking of objects we always see them mentally in their true colours, but of no particular light and shade. In fact the colour of an object helps to distinguish it

from other objects, and for that reason is important to us. Its light and shade are accidental, and not essential, peculiarities, and, being of comparatively small importance to us, are habitually disregarded by all who are not artists; so much so that the natural tendency of children when they begin to paint is to leave out the shadows altogether, and merely to paint every object with a uniform coat of its local colour. Now, although we know better than that, even as art students, yet this tendency hangs about us in a curious way, so that hardly any beginner ever makes his shadows nearly dark enough. Indeed, it requires years of training before we are aware of the true depth of shadow that a light object is capable of assuming.

It is in the correction of this tendency that the palette-knife method is so very valuable. No amount of mental prejudice can prevent the eye from passing a sound judgment on two patches of tone placed in immediate juxtaposition.

I have treated of this matter a little more fully in the theoretical portion of the book; but it was necessary to mention it here, as it helps to justify the very severe method-that I recommend.

The student should persevere for some time with this painting of still life, and on no account should he attempt landscape or figures, or live animals, or indeed anything that is apt to change its aspect, until he has acquired the power of producing an accurate likeness of a simple object. There is no reason that this kind of study should be tedious or monotonous;

with a little skill the most charming combinations of colour can be produced out of very simple materials, and, indeed, this should be part of his artistic training, to see what combinations of colour and form are harmonious and what are discordant. Unfortunately, no rules can be given to guide him in this difficult question of harmony; he must try different com binations, and not be content until he gets some-thing which he feels at once is beautiful. With a continual striving after beauty will come increased refinement of taste and certainty of judgment. At least, if it do not, it is proof positive that he has not the artistic spirit, and he had better direct his energies to some other pursuit.

When the student can honestly say to himself that his studies of still life are thoroughly accurate, he had better begin the practice of landscape. And the sort of landscape he should choose is one that most resembles the work he has been doing hitherto; that is, he should take some simple subject, seen under the simplest possible effect, and, above all, one that can be trusted to remain without much change for some time together.

For instance, he should take a bit of old wall, and only work at it when the sky is grey, leaving off painting whenever the sun comes out. The painting of sunlight must not be attempted for a long time, for it is not only difficult on account of its dazzling the eye, but it is also a terrible offender against our law of reasonable permanency of effect, as every shadow it throws is continually changing its position

Fortunately there are many grey days in England, so there will be plenty of opportunity for landscape study of the kind suited to a beginner.

The method of work should be much the same as that pursued in the painting of still life. There will be more difficulty in matching the tints with the palette-knife, as the sky will generally be found to be so bright that no paint can quite render its luminous quality ; but almost everything else can be properly matched, and this should always be done whenever practicable. The canvas should be placed well out in the open air, and should not be shaded by an umbrella, which is really only necessary in the painting of sunlight. In fact, the picture should be in much the same light as the object. Some inconvenience may be caused by the light shining through the canvas, if the sky be very bright behind it. Of course, this can always be remedied by putting something behind the canvas. A newspaper does as well as anything else, and has the great advantage of being easily procurable.

With all our precautions in choosing a simple subject, and only working in grey days, it will be found that anything out-of-doors is apt to change its colour and tone in a very perplexing way. As it is obviously useless to endeavour to correct our tones and tints every time that the landscape looks different to us, it is as well to be very careful in matching them at first, and not correcting them unless we feel quite convinced that they were wrong from the beginning. All the tones should be put in on the first

day (as in painting the still life), and unless the day
has been very changeable, we shall feel sure that they
all go well together—that is, that they represent the
same aspect of the scene; whereas, if we lay in dif-
ferent parts of the landscape on different days, the
probability is that they will not go well together,
and will represent two or more quite incompatible
effects.

Once the tones have been laid in they should, as
I have already remarked, be left unmodified, except
for very good reasons. The subsequent work should
consist in putting in the details, and, if necessary,
correcting the drawing, which can be done at any
time, as, if the subject be well chosen, its forms will
remain the same from day to day.

Of course, the student need not confine himself to
pieces of wall or bits of outhouses, though these are
certainly the best for his first beginnings. He can
try his hand at trees and shrubs; but, as a rule, he
had best not paint them too close, or all his energies
will be absorbed in struggling with the unmanageable
wealth of detail presented by the leaves and boughs,
and his attention will be distracted from the relative
tones and tints which should be his chief object of
study. He should avoid flowers for the present, as
they change too much; and he should not attempt
elaborate distant views, as these also change, though
in a different way, as they are so much more affected
by varying atmospheric conditions than are objects
in the foreground. There is, besides, the great diffi-
culty of aërial perspective, which of course must be

grappled with at some future time, but for which the student is hardly ripe as yet. I shall have something to say on this subject later on, as the difficulties of aërial perspective can be a good deal smoothed by a proper understanding of its causes.

In painting out-of-doors the looking-glass should on no account be neglected. A small hand-glass should be as indispensable as the palette, and should be constantly consulted. The so-called "Claude" glasses, or black convex mirrors, are sometimes of service, especially where the light is very strong, as they tone the landscape down until it looks more like a picture ; but one will scarcely be needed until more difficult effects are attempted.

If possible, the painter should stand up to his work, and should from time to time look at it from a distance, especially from such a distance that it looks of the same size as the bit of landscape that he is painting. When simple landscapes seen under a simple effect of light have been fairly mastered, it will be as well to proceed to the study of figures.

This necessitates much more accurate draughtsmanship than the previous studies, so the student should go back to his drawing for a while before he attempts the difficult task of painting the human figure. It is not that the drawing of figures is in itself much more difficult than the drawing of anything else, if due allowance be made for the fact that no model, however well trained, can keep perfectly still ; but that the human figure is so much better known to us than any other objects, that very small

errors in the representation of it are intolerable to any sensitive eye. An error of proportion, which would be a matter of indifference in drawing a pot or a pan, would be sufficient in drawing the human figure to turn an Adonis into a deformed cripple. This sense of form and proportion, which is strong even in people who are not trained in drawing, should be sedulously cultivated by the artist.

This sense undoubtedly was developed to its highest pitch in the best days of Greek art. Never has the human figure, as it ought to be—that is, un spoilt by disease and misuse—been so thoroughly understood as it was by the great Athenian artists. The best of the moderns can but follow falteringly in their footsteps, and even the giants of the Renaissance, in this respect at least, fell far below the standard ot Phidias and Praxiteles. The reason of this is not far to seek : it was not alone the genius with which the Greek artists were so fully endowed (indeed it would be difficult to suppose that their natural gifts excelled those of Michael Angelo), but also that the circumstances of their lives enabled them to see the perfection of the human form more frequently, and under better conditions than has been possible in any subsequent civilisation. As it is obvious that we cannot reproduce this side of the Greek life, we must do the best we can with the limited resources at our disposal. In the first place we must avail ourselves of the experience of the Greeks by studying their statues. In these we get the human form at its best—far better than we shall ever see it in the life ; so there can be no

better training in the discrimination of what is healthy and beautiful in men and women than a severe course of drawings from casts of antique statues.

But our training must not end there ; we must go to work in the same way that the Greeks did, and learn to work from living men and women. Unfortunately, the men and women who are available to us as models are mostly of a very inferior type to those splendid creatures from whom the Greek statues were carved ; still, if we take trouble enough, we can get men and women to work from sufficiently well-made not to displease even a taste made critical by a study of the antique. I think it is never worth while to work from models who are positively ugly. It is a dangerous thing to the artist to get used to ugliness in any form.

As I have said, it is a mere question of taking trouble ; we shall never find the ideal figure, but we shall find many figures that do not depart too far from what ought always to be our standard—the Greek statues.

I am afraid I cannot quit this subject without touching upon a prejudice that seems to exist in some worthy people against the employment of nude models.

In the first place, I assert most positively that without study from the nude there is no serious figure painting possible. If the artist have conscientious objections to this kind of study he must confine himself to landscapes and still life. It matters not what kind of figure-pictures he wishes to paint, he will

never be able to draw the figure properly, whether draped or otherwise, unless he has gone through a preliminary course of study from the nude. Indeed, in any case of difficult draughtsmanship of draped figures, it is advisable to put the undraped form upon the canvas first and then to add the draperies. This is a precaution against error that may not seem superfluous to even the most self-confident modern painter, when he recollects the studies that exist for many of Raffaelle's most celebrated pictures (including the Transfiguration), in which all the figures are represented nude.

Some difficulty exists in the case of ladies who are studying art, but I think it may be fairly met by the male models being partially draped, as was the custom in my time at the Slade School. To some well-meaning persons it appears particularly shocking that women should study from nude female models. I have never been able to understand this view, and I am consequently unable to argue the question. Of course there is never any necessity for men and women to study from the nude model together.

In conclusion, it may be safely said that there is something essentially false and unhealthy in the feeling that the human body is in itself indecent and objectionable, and the sooner every lover of art gets rid of this feeling the better.

Although it is not strictly within the province of this handbook, yet it may be as well to give a few hints as to the sort of drawing that is especially useful as a preparation to the practice of figure painting.

In the first place anything like elaborate stippling, or, indeed, any finicking work, should be absolutely eschewed. The figures should be carefully modelled, but the effect should always be got in the simplest and broadest way.

For this reason I strongly recommend that the shading should be done with the stump. The effect will be more like that of oil painting than any work done with the point could be, and the execution also is not dissimilar. It is also a very speedy process— which is a thing not to be despised; for, although a painter should never be in a hurry, yet he should always wish to do his work in the shortest possible time. There is too much to learn in painting for any man to allow himself to dawdle over it—so he should never do in ten minutes what he can do *equally well* in five. Of course it must also be recollected that he should never do in five minutes what he can do *better* in ten.

When a sufficient power of drawing has been gained in this way, it is as well to do one or two paintings from a cast. These paintings should not be monochromes—that is, black-and-white drawings in oil paint—but should be true paintings, reproducing with great care every variety of shade and colour in the cast. It is better that the cast should be an old one, so that it is of some definite colour. A quite new white cast is a very difficult thing to paint, and requires a delicacy in the perception of minute differences of colour which it is hardly fair to expect in a beginner. For it must be recollected that even a

white cast is not mere black-and-white : it is sure to
have colour of some sort, if only that reflected frɔm
the surrounding walls.

As regards colour, any cast is a difficult thing
to paint—indeed, almost as difficult as the human
figure ; but then it has the great advantage of
not altering its colour, as the human figure is
apt to do from day to day, and even from hour
to hour, to say nothing of its remaining quite
still.

The method of painting should be the same as we
have already described for our pots and pans ; but
particular attention should be paid to the blending of
one tint into another, so that the modelling shall
appear rounded and delicate.

When we finally come to painting the human
figure, we should still persevere with our original
method; but we must look out very carefully for
minute differences of tint : and, above all, we must
pay great attention to the texture. Quite apart
from the question of colour, any one can see that a
cast looks as if it were made of a different kind of
stuff from human flesh : it looks much harder, and
less transparent ; and this difference should be care-
fully preserved in our paintings. How, then, shall
we give the proper texture to our flesh painting ?
This is chiefly to be done by paying great atten-
tion to the edges. The outlines of a cast are
uniformly sharp all over, and should be so painted.
The human figure, on the other hand, is covered
with little hairs, too minute to be seen separately,

except quite close, but sufficiently visible to render the outlines soft and blurred. These hairs are much more abundant in some places than in others, and in some few places they are quite absent. These differences should be carefully rendered in all flesh painting. For instance, even in women they are very abundant on the upper lip, whereas they are generally absent along the ridge of the nose. Again the human skin is partly transparent, and this in itself makes the edges softer than those of a cast.

In places the colouring of the skin is slightly broken and mottled ; this is nearly always the case to some extent on the cheeks even in people with very good skins. In such places the colour must be put on accordingly ; that is, one or two different tints should be dabbed on separately, and not smoothed too much into one another. Of course, there are all sorts of differences of texture in different individuals, and they should all be carefully rendered. Wherever the skin seems rough, or covered with wrinkles too fine to be seen separately, the paint should be put on roughly ; and generally in the first painting the brush-marks should be so put on as to indicate the general direction of any furrows or crinkles in the skin. Hair should be painted with a large brush in the first place, and every endeavour should be made, by brushing the paint on lightly and dexterously, to indicate the lie of the separate fibres. Then in the finishing, wherever a stray hair or two are seen definitely from a consider-able distance, they should be put in separately with a writer brush.

D

Of course, not much can be done in words to explain all the difficulties of flesh painting, but the learner must persevere until his picture looks fleshy; if it will not look like flesh he must ask himself why it does not, and to such a question, honestly put, he can generally find an answer.

The study of draperies should now be begun in good earnest. It is as well, in the first stage of still-life painting, to introduce a bit of stuff here and there, and carefully study its folds; but for the systematic study of draperies there is nothing like a lay figure. It is true that these substitutes for the living model should be looked at very askance, and discarded whenever practicable; but it is too much to ask a beginner to paint draperies carefully from a living model who is quite certain to disarrange them before an hour has passed—and, once disarranged, they can never be put back again. It is very difficult to draw folds well, and it is essential that the beginner should be able to work away at them until he has thoroughly rendered all their delicacies. Every different kind of stuff goes into a different kind of fold, and it is hopeless to try to render the texture of draperies without paying great attention to the character of the folds. Once arranged on the lay figure, they can be studied day after day until the student feels that, given sufficient time, he can paint any drapery in a satisfactory manner. He should then endeavour to shorten the necessary time until it is possible to finish simple bits of drapery during the short time that the living model can keep quiet. Indeed, his constant aim

should be to acquire such masterly rapidity that the lay figure can be dispensed with, and all draperies painted from the model; but the preliminary practice from the lay figure is indispensable, as giving a standard of accurate work which must be preserved with great care, even when the conditions are much more difficult.

Before I quit the subject of figure painting I must say a few words on anatomy.

Now, it is quite possible to overrate the importance of anatomy to the artist; no amount of knowledge of bones and muscles can allow us to dispense with direct observation of the figure whenever we wish to paint it, and this observation of the surface of the figure is quite sufficient to enable us to paint it well without our troubling ourselves with what there is beneath the surface. It is true that when our models are poor and ill-defined in form, a knowledge of anatomy is of service in enabling us to supplement their deficiencies; but, even then, the study of antique statues is more valuable, as it is one thing to know the shape of a muscle or a bone in themselves, and another to know what they look like when covered with skin and padded with fat. No one has ever equalled the ancient Greek artists in their knowledge of the superficial aspects of the human body, but it is certain that they were almost entirely ignorant of anatomy.

At the same time, I will not deny that a study of the more obvious facts of anatomy is useful to the student, especially in the representation of motion,

D 2

where, of course, direct observation of the model does not help us much; but we must always be on our guard against letting our knowledge override our observation. There is hardly anything in art more offensive than an elaborate display of misplaced anatomical knowledge, such as figures showing every muscle in their bodies, " looking," as Leonardo says, " for all the world like bags of walnuts." In fact, anatomy is a good servant, but a bad master. Unless great care be used it is apt to encourage that (artistically) pernicious tendency of the natural man to represent things not as he sees them, but as he imagines they really are.

The next stage may well be the study of portraiture. This is especially valuable as giving a new standard of accuracy; we have hitherto been content to make our pots and pans like pots and pans, and our human beings like human beings. Now, to make a picture which shall not only be like a human being in general, but so like one human being in particular that all his friends and relations shall agree that it is like him, demands a much further degree of accuracy.

I shall have something to say on the subject of true portrait painting, which is a very difficult and highly specialised kind of art; but the sort of portraiture that I should recommend to the student is a very different matter, in which hardly anything should be aimed at beyond mere accuracy of resemblance. For the purposes of study the sitter should be treated as a model, and kept as still as possible, whilst the

painter's sole endeavour should be to represent him as he looks at the moment, without any regard to his most characteristic expression, or his most favourable aspect. But a good likeness must be aimed at, or that special test of accuracy will be missed which consists in the picture resembling one particular human being, and resembling him so strongly that there can be no shadow of a doubt for whom the picture is meant.

Such is, roughly, the course of study that I should recommend. It should be persevered with until the power has been gained of accurately representing anything that will remain still enough to be copied directly from nature. If pursued with due earnestness it will be found very interesting, and although to some soaring spirits this humdrum accuracy may appear very degrading, it must be recollected that it is only a means to an end, and that without a certain power of depicting natural objects the most poetic imaginings must fail to produce their proper pictorial effect.

It is true that, so far, the student has been prevented from exercising either his imagination or his memory. His painting has been the result of simple observation, nothing more. Now, I should never think of denying that imagination is a quality to be cultivated, and that memory is essential for the painting of fleeting effects; but there is a time for all things, and these qualities should be kept in abeyance for the present, for, if indulged in too early, they can hardly fail to be fatal to that habit of accuracy which is the foundation of all good painting.

When this accuracy has become a second nature with the painter, then he may, and, indeed, ought, to indulge his imagination; but not before. If he has the right stuff in him it will be none the worse for keeping ; indeed, there is nothing so deadening to the imagination as to try to express it with inadequate means.

We will now endeavour to advance a step beyond the mere copying of what we see before us.

The choice of a subject for a picture is one of great difficulty. That this is so may be readily inferred from the fact that the old masters went on painting the same narrow range of subjects one after another; while the moderns, in their efforts to be original, generally succeed in getting extremely bad subjects.

A really good subject should be in the first place interesting ; that is, it ought to arrest our attention and set us thinking. It ought, if possible, to be beautiful, and it ought to more or less explain itself ; that is, one should be able to guess at the general nature of the incident without having recourse to an elaborate written explanation. It is true that many fine pictures do not fulfil these requirements, but I venture to think that they would be still finer if they did. Of course the finest subject in the world can only make a bad picture if it be badly painted. In fact, the finer the subject, the more it is necessary to paint it well ; and I hold it to be equally true that a picture that is fine in drawing and colouring is a fine picture, even if it have no subject at all.

This latter truth is one not readily recognised by the outside public ; but artists are so much impressed by it, that they will often say that a picture is the better for having no subject at all. I distinctly differ from this opinion ; but I think that no subject is better than a bad one—*i.e.*, a radically unpictorial subject, or one that is inadequately treated.

It is customary to divide subjects into two classes —historical and genre ; but the line between them is very difficult to draw. To my mind the great distinction is between modern and non-modern subjects.

For many reasons modern subjects ought to be the best.

After all, what is going on around us at the present day is more interesting to a healthy mind than all the records of the buried past. And again, modern subjects have the great advantage that they can be so much more truthfully rendered. All historical painting is more or less guess-work, and is certain to be false in many particulars ; a falsehood which may pass muster to-day, but which will probably be found out eventually, as historical research advances.

But then comes another consideration, which almost irresistibly drives us back upon the past.

For one cause or another our modern life is ugly, especially the side of it with which the painter comes in contact. There probably never has been anything so unpictorial since the world began as the ordinary appearance of our respectable classes, and it is amongst these worthy but unpictorial people that the painter mostly dwells. There are still elements of

picturesqueness to be found amongst the labouring classes, but even these are getting scarce. However, there is undoubtedly good work to be done here, but it must be done thoroughly, and not merely looked at from a distance. No one has ever painted peasants like Millet did, but then he was a peasant himself, and lived amongst them. For the painter who can live amongst the common people, and can thoroughly enter into their lives and habits, there is the possibility of most interesting pictures. Of course, for picturesqueness we must go to the rural poor ; but even the poor of the great cities afford splendid mate rial for the sympathetic painter—for their lives offer scenes where pathos or dramatic intensity can amply atone for the lack of beauty. But there are not many artists who are content to do this, and, indeed, it is hardly to be expected of them, for we all love association with kindred spirits, and whatever virtues the poor may possess, an appreciation of art is not one of them. Again, there is too much absolute ugliness in their lives inbetween the flashes of picturesqueness, to make living in their midst other than painful to a sensitive artist. So for the most part we are content to go to history for our subjects—if we have subjects at all, and do not confine our art to the painting of single figures of attractive young women doing nothing in particular in various costumes.

For one thing, the field of history is so vast that it is very odd if we cannot find something in it that will suit our taste.

Are we fond of gorgeous colouring, rich stuffs, and costly accessories? There is the whole of the Middle Ages to choose from, culminating in the Italian Renaissance, when perhaps the brilliancy of life attained its highest development. Do we love the human figure? We have only to turn to classical times and we shall find plenty of subjects which give scope to all our draughtsmanship and powers of flesh painting. Then, if we wish to paint beautiful people, untrammelled by any considerations of historical accuracy, we can revel in the whole field of Greek and Roman mythology. Or if we wish our painting to appeal to the most deep-seated feelings of our race, we can choose our subject from the Old and New Testament—which perhaps is the best choice for a mediocre painter, who feels that his pictures are hardly good enough to be liked for themselves alone. But whatever period we choose, and whether we treat some well-known historical incident or simply confine ourselves to some possible, if unrecorded scene, we should spare no trouble to make our picture consistent with the best attainable knowledge on the subject.

Some painters are apt to spare themselves this trouble, and think they are giving proof of imagination when they are only showing their ignorance; but there can be no excuse for carelessness in this respect. There is plenty of scope for imagination in animating the dry bones of archæology. Imagination is not antagonistic to knowledge. On the contrary, the highest imagination is that which can assimilate all

kinds of knowledge and make use of it as a vantage
ground from which to soar to higher things.

When the subject has been chosen, what is the
proper course to pursue ?

Before making the slightest sketch, before even
thinking of the composition of the picture, the painter
should familiarise himself with all the surroundings
of his subject. He should know how the people
were dressed—if they are historical characters, what
they looked like—what were their habits and customs,
what houses they lived in, what scenery surrounded
them. Having got fairly clear ideas on all these
points, he should let his imagination play round the
subject, until it seems to make some kind of mental
image. If this mental image appear to be fairly
well suited for a picture, a rough sketch should be
made of it in charcoal. Should the image seem
hopelessly unpictorial, the subject must be turned
about in the mind until some image of better promise
appears.

When the charcoal sketch has been made, the
figures should be altered and shifted about until the
lines of the composition seem fairly satisfactory.
Then a little coloured sketch should be made, with no
pretensions to accuracy of any kind, but merely giving
the rough idea of the colouring and the light and
shade. This also should be knocked about until the
result seems promising. Then models should be
selected with great care as appropriate as possible to
the personages of the picture.

It sometimes happens that a model with an

unsuitable figure will have a suitable face, and *vice-
versâ*. When this is the case, two models or more
must be employed for one figure ; but this should
be avoided if possible. If the figures be in difficult
positions, or if they be required to represent people
more beautiful and graceful than ordinary humanity,
they should be drawn in carefully from the nude
before any costumes are attempted. If action have
to be represented, it is as well to make separate
studies in charcoal. These studies should be as rapid
as is consistent with a fair amount of accuracy, and
should keep more closely to the model than is quite
advisable for the picture. When a satisfactory study
has been made, it can be copied on to the picture with
as much added vigour and grace as the draughtsman
is capable of giving.

Of course, we must here abandon all idea of
slavishly copying the model. If action is required
no model can possibly take up the right position for
more than a very short space of time, if, indeed, it
be possible to take it up at all. The artist must get
an intelligent model, and work as best he can from
momentary glimpses. He must give the model
plenty of rest, and trust more to his memory than to
actual copying. Again, very few models are suffi-
ciently well proportioned for ideal or classical figures ;
so the drawings made from them must be corrected
from a knowledge of the antique. Indeed, it is an
excellent thing to have a cast or two from really fine
statues to refer to from time to time, but they will
not be of much use unless his previous training from

the antique has well saturated the painter's mind with a knowledge of fine proportions.

Most of the female models of the present day are apt to be stumpy, *i.e.*, short in the leg. This must be corrected in all figures with any pretension to dignity or grace. The fault generally lies chiefly in the lower leg, that is, from the knee downwards.

The requisite costumes must either be hired, or, if this be impossible, made for the occasion. There are costumiers in London with a very good collee-tion of mediæval and last century dresses. Greek costumes are so simple that they had always best be made.

One thing should be recollected in painting classical costumes, and that is, that we have derived from the statues a very erroneous idea of their plain-ness and absence of decoration.

The vase - paintings and the little terra - cotta figures abundantly prove that they were often elabo-rately ornamented and brightly coloured. I have found myself that questions of Greek and Roman costumes are very satisfactorily dealt with in Rich's "Dictionary of Antiquities," which, indeed, in all respects, is particularly valuable for the sort of in formation required by artists.

In anything like elaborate draperies the great difficulty arises of how to paint them from the living model. Of course the model cannot keep still in-definitely, and once folds are disarranged one can never get them back again into the same condition ; on the other hand, if the draperies be arranged on the

lay figure, they are sure to look stiff and lifeless. I think, wherever it is possible, they should be painted from the living model, a bit being finished at a time, and then a new bit being taken up after the model has rested ; but where the draperies are too elaborate to be treated in this manner, they should be roughly sketched in from the living model, and then arranged in as nearly as possible the same folds on the lay figure, from which they should be finished, the main lines of the first sketch being scrupulously adhered to. The accessories should be painted, wherever it is possible, from real objects. Where this is not possible, real objects should be selected which somewhat resemble the required forms. With a little practice very realistic results may be obtained in this way.

If the background be a landscape it should be painted from an actual study of some similar scenery, aided, if necessary, by photographs of the country where the incident takes place. If the background be a building, it must be carefully drawn in, according to the rules of perspective, with all the architectural details taken from the best authorities. In the painting the light and shade should be carefully calculated, and, when possible, studied from some actual building which more or less resembles the ideal one.

In painting the figures a background should be put up behind the model which more or less represents the background of the picture, and great care should be taken to arrange the lighting of the studio so as to resemble the lighting of the picture. This is, of course, difficult when the scene is supposed to take

place out of doors; but even then it is generally possible to paint in a conservatory, or even in a garden. But where this is not possible, the painting from the model must be modified by observation of how people look out of doors.

In spite of all these precautions, it is likely enough that the picture will miss that air of reality that we have striven so hard to impress upon it. Well, if any particular part of the picture seem at fault, it must be ruthlessly scraped out and painted over again. It will at first be found difficult to avoid a patchy effect from thus taking out and repainting isolated bits; but a little practice will soon prevent the patchiness from being at all glaring, and it is certainly hopeless to endeavour to paint a picture that will not require alteration. When all is done that can be done the picture should at least look *real*. Of course, it may be badly composed, and entirely dull and unimaginative; but even then it will not be utterly despicable if the individual parts be well painted; and if the imagination be there it will strike the spectator the more vividly in that the scene looks real.

It is possible, and indeed very advantageous, to combine with the painting of subject pictures some other branch of our art, such as portraiture or landscape painting. When portraiture is taken up seriously for its own sake, and not merely as a means of study, it becomes a very elevated and difficult form of art. It is true, it makes no demands on the imagination, and the problems it presents are very simple; but from their very simplicity arises a special difficulty.

How is it possible to make an interesting picture out of a commonplace person in the costume of the present day? It must be acknowledged that in some cases the problem is hopeless. There are some portraits which, at the best, can only be interesting to artists on account of their technical merits, but which to the general public must be simply ugly and dull. But it is seldom, after all, that we come across an absolutely commonplace subject; when we do we must resign ourselves to it, for it would be contrary to the fundamental principles of portraiture to make the picture other than commonplace. But we can always endeavour to paint it well, and make it like and characteristic, and that in itself is no small achievement.

There are one or two general considerations which ought to guide us in our treatment of portraits.

In the first place, the painter has a duty towards the people who give him his commissions. He must do his best to please them, in so far as he can do so without violence to his artistic conscience. That is, if they want a profile, he must be prepared to do them a profile, even if he should himself prefer to do a full-face; again, they should be given a voice in the question of the costume the victim should wear, and even, if necessary, as to the sort of expression he should put on. Of course, the artist should give his advice on all these points, but he need not insist on its being followed. After all, he ought to be able to paint a good portrait of a man in a uniform as well as in a shooting-coat, and most men have different

expressions at different times, and any expression
that a man often puts on is fit to be immortalised in
his portrait.

But there are some points that the painter should
be firm about. He should never flatter his sitter ; he
should paint him at his best, if he can, but that is all.
He should never make him younger or better looking
than he is, nor give him an amiable expression if he
never does anything but scowl, nor put him in a
graceful attitude if he is essentially ungraceful.

These things are against the artistic conscience,
and no amount of entreaty should make the artist
yield an inch in the direction of flattery ; but when
there is a legitimate choice of treatment, then the
family should have their way. After all, it is they
who have to live with the picture.

But supposing the choice in all these matters is
left unreservedly to the painter, what principles ought
to guide him in the composition of his picture ? The
main thing to be borne in mind is that the portrait
must be characteristic. The costume should be one
that is often worn by the sitter ; the pose must be one
that he naturally assumes ; the accessories must be in
accordance with his habits and tastes. His expression
must also be fairly habitual ; not a mere momentary
one, which gives no clue to his character. Within
these limits the painter should endeavour to make his
sitter and his picture look their best ; that is, he
should put his sitter in the light and shade which
best suits him, and should arrange the colouring and
accessories of his picture so as to produce the most

harmonious whole. This is a matter of considerable difficulty, even in such a simple thing as a portrait ; and nearly the whole of the first sitting can be profit ably spent in arranging the picture. Then the artist should struggle manfully to prevent his sitter from being bored. This is one of the great difficulties of portrait painting, and can in most cases be best met by encouraging the sitter to talk. Talking to him is not nearly so efficacious, besides being much more distracting to the artist. If the sitter will not talk, the next best plan is to get some one to read to him ; but amused he must be at all costs, or the portrait will inevitably reflect the patient misery of the sub- ject. Nor should the sitter be bullied about sitting very still ; of course, he must not be allowed to fidget too much, but a man who is always thinking of his position can hardly help looking awkward and constrained ; and above all, he must be given a rest whenever he wants it : and, even if he do not want it, he must have one as soon as he looks tired.

When all is done that can be done, the success of the portrait will depend in a great measure on whether the sitter be a good subject or not, and unfortunately the professed portrait painter can hardly pick and choose ; but there is nothing to prevent his looking out for interesting sitters amongst his friends and acquaintances, and offering to paint them for nothing —an offer that will seldom be refused. In this way he can always be sure of having some interesting por- traits to do if he be willing to make some slight pecuniary sacrifice.

E

Landscape painting can very well be combined with the other two branches ; it makes an admirable relief to portrait painting, and is a useful training for figure pictures, which are too often spoilt by the poverty of their landscape backgrounds.

There are two ways of painting landscape, both of which, in competent hands, have yielded admirable results. One is to concentrate one's attention on evanescent effects ; the other to give, as it were, a portrait of a scene in which the effect is subsidiary to the rendering of form and local colour. The first, to be well done, requires great knowledge and study, and is best adapted to the professed landscape painter, who can give his whole time to the pursuit. The second is more fitted to the portrait or figure-painter, who wishes to take up landscape as a relief from his other work. Turner's landscapes are typical of the one kind, Millais's of the other The methods suitable to these two kinds of landscape painting are essentially different. The first must necessarily be done from studies, most of them very rapid and incomplete, aided by memory and knowledge. The second kind should be painted entirely on the spot, by which means a wealth of detail and a truthfulness of colouring can be attained which can never be rivalled by studio work.

If the picture be of any size, a shed should be built in which the painter can stand whilst at work. The front and one side should be open to give plenty of light ; a roof and two sides facing towards the prevailing winds will generally be shelter enough. Of

course, if the roof can have the luxury of a skylight, so much the better. The shed can then have three walls, being merely open towards the landscape. I believe that Millais's landscapes were all painted in this way; at any rate, the best of them were so painted, so there can be no doubt as to the possibility of producing quite first-rate works by this method, which is the one I should recommend to all who are not professed landscape painters.

I need not pursue these practical hints any further. I will add a short account of what I have been able to gather as to other methods of work, and I will then treat of the theoretical principles which underlie the whole art of painting, some of which will be found of considerable practical utility.

———

I will begin my account of some other methods of oil painting with the directions drawn up for the South Kensington Schools by Mr. Poynter, and which, on account probably of their unbending character, are called by the students " The Laws of the Medes and Persians "·—

DIRECTIONS FOR OIL PAINTING, DRAWN UP BY THE PRIN-
CIPAL OF THE NATIONAL ART TRAINING SCHOOL, FOR
USE IN THE SCHOOLS.

Monochrome Painting.

Colours to be used : Flake White, Raw Umber, Blue Black and when the colour of the cast requires them, Yellow Ochre, Raw Sienna, Burnt Sienna.

E 2

Mix up a tint with the palette-knife :—
For the Shadows.
For the darker Half-tint.
For the light Half-tints or general colour of the Casts.

Match the tints with the knife against the cast, so as to get the colour as true as possible. The tints must be of the *prevailing* colour of the shadow, or half-tints required.

If there is any quantity of strong reflection in the shadows, which contrasts in a marked manner with the cast shadows, mix up an additional tint for the reflections.

N.B.—In matching the tints against the cast, the knife must be held in the full light between the eye and the cast, but so that there shall be no " shine or glare " on the paint.

If the student is working in the full light of the window, and the cast is in the darker part of the room, he must go near to the cast to match the tints, or they will be too dark ; otherwise he may match them from his place.

Make a careful outline of the cast in charcoal, and before beginning to paint, draw in the outline with a sable brush filled with raw umber thinned with turpentine. *It is most important* that the outline shall be finished and correct before beginning to paint.

The painting should be so done that it should be finished at the first painting ; it is therefore necessary that no more be begun in the morning than can be completed in the day.

First lay in the shadows with the shadow-tint, painting a little over the line of transition between the light and shade, so as to have some colour to paint into. Next to this lay in the darker half-tint, painting it into the shadows, but not passing beyond the transition line, or the drawing will be lost ; and carry this tint as far as necessary toward the light, mixing with it some of the lighter half-tints as it graduates towards the light, following of course the gradations and drawing of the cast.

Next cover the lighter parts with the lighter half-tint, and if the spaces of highest light be large, mix white with the tint, imitating the gradations in the cast.

Next paint the reflections into the shadows, mixing white, or

white and yellow ochre, or yellow ochre only, with the shadow-tint to lighten it, according to the greater or less degree of warmth in the reflection ; and paint in the darker parts of the shadow (picking out the forms) by mixing raw umber, black, and raw or burnt sienna, with the shadow-tint, following in each case the gradations in the cast.

Next get rid of any too abrupt transition between the shadow and the darker half-tint by laying on intermediate tints between them, being most careful not to lose the drawing at this part, which is the most difficult gradation to render in the painting.

In the same way correct any false tones in the half-tints by laying on the right colour over the places which are wrong.

Finally, when the modelling is complete, put on the highest lights with a full brush, taking care that the colour used is absolutely right.

If these directions are attended to, and the right tints are laid on in the right places, there will be no need to re-touch ; and the work may be taken up the next day where it was left off.

To prevent an awkward join between the two days' work, do not leave off at an outline, but carry the paint a little over the edge ; and begin the next day's work with some of the same (or exactly similar) colour, painting a little of the edge of the previous day's work ; the join will then not be visible.

No glazing is ever necessary. *Use no Medium.*

Use round brushes rather than flat, as it is impossible *to draw* with flat brushes ; but flat brushes may be used to cover arge spaces, and are occasionally useful in other cases.

If the work when dry is entirely wrong, it may be re-painted in solid colour, without medium ; but if, when the whole work is completed at the first painting, re-touching or more finish is necessary, a little oil or other medium rubbed thinly on will enable the student to work over in thin colour.

There is no reason why one painting should not be sufficient, as practice will enable the student to produce highly modelled, correct, and finished work ; but it must be understood that the painting is not to be left rough or unfinished in execution.

Painting in Colour.

Proceed exactly as in Monochrome Painting. The colours to be used in flesh are ·—

Flake White.	Burnt Sienna.	Raw Umber.
Yellow Ochre.	Light Red.	Burnt Umber.
Raw Sienna.	Vermilion.	Blue Black.

Terra Verte and Cobalt may also be used.

It will be seen at once that my system is merely a modification of Mr. Poynter's. Indeed, I have derived it directly from his teaching at the Slade School, where I was one of his students. Nevertheless, I have some criticisms to make on the laws of the Medes and Persians, which may serve to show the points of differ ence in the two systems.

My first criticism is purely verbal. What is described as monochrome painting is nothing of the kind; it is merely the painting of an object which has got very little colour in it. True monochrome painting is like a drawing: it makes no pretence to reproduce the colour of the object depicted. But the essence of this system is that the colour should be rigorously matched. One of the complaints I have to make against the rules is their want of generality. Painting a cast is the same sort of thing as painting anything else, and does not require directions all to itself; nor do I think it good to recommend a special assortment of colours for the purpose. It is better that the student should always be equipped with his full palette. Even in a cast a tint may crop up which cannot be properly represented by the limited assortment of colours recommended by Mr. Poynter,

The want of generality applies also to the routine suggested as to the first laying on of the shadow, &c. If the cast be in full light, there is practically no shadow ; but the painting of an object in full light is as valuable an exercise as any other—indeed, in some ways, more valuable. It is better, in my opinion, to give the general rule: that a separate tint should be mixed for every considerable patch on the object that has a different colour from the rest. Whether this difference depends on local colour or on light and shade is quite immaterial.

Another small criticism is that I object to the recommendation of round brushes rather than flat. It is quite untrue that it is impossible to draw with flat brushes, and they have the great advantage that they will give a broad or narrow touch according to the way in which they are held. With a round brush it is impossible to modify the touch to nearly the same extent as with a flat one.

But my chief criticism concerns the injunction to finish a bit at a time. Now, it is quite true that in this way a certain freshness of execution is gained which is very attractive, but I hold strongly that for the student execution is of minor consequence. It will be sure to come with practice later on, and can fairly be left to take care of itself for the present. If the student pay too much attention to his execution he is sure to neglect the really important matter, which is to secure absolute truth of tone and tint. Now, it is very difficult to attain this with one painting, especially as it is almost impossible to judge of the

correctness of isolated tones when the rest of the canvas is blank. The great advantage of filling up the canvas at once is that then all the tones are seen with their proper surroundings. It may be said that with the rigorous use of the palette - knife the tones are sure to be right, whatever their surroundings may be ; and it is quite true that they will not be far wrong if the method be pro perly pursued. But, after all, it is rather a rough and ready way of securing accuracy : invaluable as laying a foundation, but not sufficiently delicate for the finishing. To my mind, the true method is to use the palette-knife to get a roughly accurate general map of the different tones and tints of the object, and then to modify this sketch by painting thinly over it until a much greater degree of accuracy has been gained. But to do this the eye must have every advantage. It will never be able to compare accurately a mere patch of colour in the middle of a white canvas with the portion of the object it is intended to represent, surrounded by all sorts of colours. Again, quite apart from the question of colour, it is too much to expect of a student to get his detail and his texture quite right at the first painting. He ought to aim at it, but he certainly will not achieve it, and he must never hesitate to correct anything which seems wrong, even at the risk of making his painting look messy. But, further, in the painting of pictures, it is well known that it is almost hopeless to endeavour to arrive at a true general effect by finishing each part at a single sitting. As a rule, every bit of it has to be

worked on again and again until the whole comes right. And as this working over and over is very difficult to do without getting into a mess, so there is every reason that the student should practise it from the beginning.

It is true that there are some painters who do contrive to finish their pictures bit by bit, each part of the picture showing only one painting ; but it is im possible to do this with any success without con tinually scraping out bits that are not good enough, and painting them over again from the beginning. If this be done with great patience and determination, the result may be good ; but it will be generally found that the picture is patchy, and that freshness of execution has been gained at the expense of the far more valuable qualities of general truth and of harmony of effect. At any rate, it is beyond dispute that the finest pictures have been painted by the other process: that of continually working over and over until the requisite effect has been gained.

It may be useful to compare with Mr. Poynter's method the one pursued in Paris, at the well-known *atelier* of M. Carolus Duran, an account of which has been given me by a friend, and which I will reproduce nearly in his own words :—

" The model was posed on Monday, always in full light, without shadow effect, and against a strongly coloured background, which we had to imitate exactly in its relations to the figure. The figure was drawn in in charcoal, then we were allowed to take a sable and strengthen the outline with some dark colour

mixed with turpentine, but not to make any prepara-
tion, nor put in conventional brown shadows. The
palette was set as follows :—

"Black, verte émeraude, raw umber, cobalt, laque
ordinaire, brun rouge or light red, yellow ochre, and
white (the colours being placed on the palette in this
order from left to right).

"We were supposed to mix two or three grada-
tions of yellow ochre with white, two of light red with
white, two of cobalt with white, and also of black and
raw umber to facilitate the choice of tones.

"We were not allowed any small brushes, at any
rate for a long time—many months or years.

"On Tuesday Duran came to criticise and correct
the drawing, or the laying in of the painting if it was
sufficiently advanced. We blocked in the curtain first,
and then put in the figure or face in big touches like
a coarse wooden head hewn with a hatchet ; in fact,
in a big mosaic, not bothering to soften things down,
but to get the right amount of light and the proper
colour, attending first to the highest light. The hair,
&c., was not smoothed into the flesh at first, but just
pasted on in the right tone like a coarse wig ; then
other touches were placed on the junctions of the big
mosaic touches, to model them and make the flesh
more supple. Of course, these touches were a grada-
tion between the touches they modelled. All was
solid, and there were no gradations by brushing the
stuff off the lights gently into the darks or *vice versâ* ,
because Duran wished us to actually make and match
each bit of the tone of the surface. He came again

on Friday to criticise, and on that day we finished off."

It will be seen that this system bears a considerable resemblance to Mr. Poynter's, the chief difference being that M. Duran does not consider it advisable to finish each bit at a time, but prefers, as in my method, that all the tones should first be blocked in very coarsely before any of the finishing touches are given.

Of course there are many other methods practised at Paris, but they most of them go on the same principle of seeking first of all for absolute truth of tone and colour, and getting this truth in the simplest and most obvious way.

I have already mentioned the method pursued by Sir John Millais : that of putting the canvas side by side with the object, and walking backwards and forwards between each touch. Now, in many ways this is an admirable method, and is particularly well adapted for students, on account of the direct comparison that it gives between the picture and the object painted. But it has serious drawbacks; the chief of which is that it leads to a certain looseness and sketchiness of touch, which is certainly not advisable for a student, however charming it may be in the hands of a master. Every touch that is given by this method has to be applied by memory, and not by direct observation, for the painter can only see his object properly when he is away from the canvas. He then walks up to his canvas, puts on his touch, and comes back again to see if it be right. As it is

generally more or less wrong, it has to be corrected until it is right. So that the whole process is one of continual correction, a process which is hardly compatible with great firmness and precision of drawing. At the same time, it must always be remembered that if the next thing to being right is to be wrong with precision, yet it is distinctly better to be right, whether with precision or otherwise.

Another drawback is that the process of walking backwards and forwards is so irksome that the painter is apt, out of sheer laziness, to stop too long at his canvas, and to paint his picture from the view he gets of his object when he is quite close to it — a fatal proceeding, as it is quite impossible to get a good general view of an object until one is some way off it. Of course a very resolute painter can avoid this danger, but human nature is weak, particularly artistic human nature.

So far our methods have been very direct—that is, they have aimed at painting things at once as we see them, without any preliminary preparation beyond that of a careful outline drawing. But some artists have considered that it is as well to separate the difficulties of colour and of light and shade, and to attack them separately. There are various methods founded on this principle, the most thorough-going of which was a good deal practised in England about thirty years ago. It was called the Murray method, and consisted in modelling the subject very carefully in a sort of purplish-grey, called Murray (or mulberry) colour. When the modelling was complete the colour

was added by thin glazings of transparent pigments. Of course, the great objection to this method is that it is impossible to get anything like really accurate colouring by means of it. No glazings can sufficiently modify a dark neutral ground to give anything like the true intensity of hue that is to be found in a great many shadows.

There is a letter of Sir Joshua Reynolds which gives a very good account of such a method. He is describing his own practice in 1770, when he was forty-seven years old—that is, in his prime :—

" I am established in my method of painting. The first and second paintings are with oil or copaiva (for a medium), the colours being only black, ultramarine, and white." " The second painting is the same." " The last painting is with yellow ochre, lake, black, and ultramarine, and without white, re-touched with a little white and the other colours."

Of course, in the hands of a genius like Reynolds a great deal can be done with even an unsatisfactory method ; but it must be noted that although a fine colourist, he was not by any means a rich one. It is also probable that his first painting was very pale, so that the dulness of his black and ultramarine was easily conquered by the richer colours with which he finished his pictures. Much less objection can be taken to this system if the palette which is used in the first painting is slightly enriched, so that a suggestion can be given of all the colours of the original. The picture, in its first stages, will then be a pale and washed-out version of the scene it represents. In the

later stages the colour is reinforced with all the resources of a full palette until the requisite vigour and richness has been gained.

It would seem as if Titian's practice were of this kind. In Mr. Hamerton's very interesting and learned work on the graphic arts, from which I have already borrowed my account of Reynolds' practice, is to be found a *résumé* of what Boschini tells us with regard to Titian's method. This Boschini knew the younger Palma, whose father had received instruction from Titian, so it is probable that the tradition handed down by him is not very wide of the mark. It seems that Titian painted his pictures at first very solidly, with a simple palette composed of white, black, red, and yellow. There was apparently no blue, but black and white make a bluish-grey, which would be sufficient to indicate this colour in the first painting.

Boschini speaks of four pencillings which were done in this way, and then the picture was put aside for several months. When he took it up again, he first amended and corrected all the forms. He then finished very laboriously with continual glazings and with rubbings of opaque colour, frequently applied with the finger instead of the brush. In this way he gained the exquisite subtlety and richness of colour in which his paintings surpass all others. I shall not attempt to criticise a method which has produced the finest paintings that the world has ever seen, but I certainly think it is too elaborate for a student to practise. He should aim at the representation of nature in a rather commonplace and obvious way,

and should keep subtleties of colour and execution till the student stage is over.

Leonardo appears to have laid in his pictures with a warm brown, and this also was the practice of Teniers and the Dutch painters generally. Now, a warm brown is a very pleasant colour in itself, and also affords delightful greys when other colours are thinly scumbled over it, so that paintings produced in this way are generally agreeable in colour ; but they certainly do not represent the true variety and richness of natural colouring. A grey-brown world may be very harmonious, but the actual world we live in shows much finer colouring than that. Of course the brown ground can be modified to any extent in the subsequent painting ; but in practice it is rather apt to pervade all pictures painted in this way, and there is the additional disadvantage that the groundwork of all oil-paintings is apt to become more conspicuous with time. That a white ground should shine through the colours above it a little more than was originally the case is hardly a drawback, and would certainly not interfere with the general richness of colouring ; but with any dark ground the case is different. All oil painting has a tendency to grow darker with age, and it is obviously unwise to hasten this tendency by using a dark ground, which becomes more and more conspicuous every year.

I think it is not necessary to give any further details regarding different systems of painting. Any one who is curious in the matter can find in Mrs. Merrifield's " Treatises on the Arts of Painting," a

careful collection of all that is known with regard to the methods of the old masters, and it is very odd how little *is* known about them. What accounts we have are extremely vague, and mostly contradictory. Again, Mr. Hamerton has collected some very interesting notes as to the practice of some modern painters, which can be found in the " Portfolio" for the years 1875 and 1876, and again re-written and considerably added to in the work I have already mentioned, " The Graphic Arts."

In conclusion, I must utter a word of warning as to taking too literally the accounts that artists give of their own methods. They always imagine that they set to work much more systematically than is really the case. As new difficulties arise they invent new means to conquer them, and as new difficulties always are arising their systems are continually being modified. At the same time, it is difficult to do good work with a complete absence of system, and there is little doubt that an adherence to some kind of definite method does very much to simplify the laborious process of learning how to paint.

Part II.

THEORY.

So far we have confined ourselves to practical matters ; we will now consider the theoretical principles which underlie the art of painting. To some people it may seem strange to put practice before theory ; I can only allege as my justification, that in so doing I am following the natural order, for no valid theory of anything has ever been made until we have practically found out a good deal about it. Nor is it possible to thoroughly understand a theory until we are more or less familiar with the facts on which it is based.

There are other people (amongst them many artists) who will scout the idea of there being any theory of painting at all, and who are exceedingly indignant at any search after scientific principles to elucidate the hidden ways of art. Fortunately, this attitude is becoming less common as science in general is becoming better understood. After all, science is neither more nor less than knowledge, and there are few people now-a-days who will maintain that we shall do anything the better the less we know about it.

In the first part I have thus stated the problem set before the student:—" Every natural object appears to

F

us as a sort of pattern of different shades and colours ; the task of the artist is so to arrange his shades and colours on his canvas that a similar pattern is produced."

We will now consider this matter a little more closely. In what does the sense of sight consist ?

Unfortunately, to answer this question, I must refer, however briefly, to the constitution of the universe.

It is generally held by people who are qualified to have opinions on the subject, that matter consists of exceedingly small particles, not close to one another, but with spaces in between, and that these spaces are filled by an all-pervading something, called the ether, which is, perhaps, made up of still smaller particles, or is, perhaps, structureless. We do not know much about the ether, but we do know that it can vibrate, and that vibrations travel through it with extreme rapidity. It is these vibrations (or, rather, some of them) that constitute what we call light. Now, our eyes are an apparatus which is so arranged as to be affected by these vibrations : that is to say, they set up some kind of agitation in the nerves which end in the retina, and when this agitation reaches a certain portion of the brain a sensation is excited which we call sight.

It has been said that the ether fills up the spaces between the particles of matter; it is the motion of these particles that sets up the vibrations in the ether. These particles are never actually at rest, but are always vibrating to and fro. When anything is

hot we imagine that the particles are vibrating very rapidly ; waves of corresponding rapidity are transmitted through the ether, and when these waves reach our skin they produce that state of our nerves that we call the sensation of heat.

When the rapidity is very great the ether vibrations are capable of exciting the nerves of the retina ; we then have the sensation of light. As regards the vibrations of the ether, light and heat are essentially the same ; the difference lies in the apparatus that perceives them. It is only waves within certain definite limits of rapidity that excite the retina, and even within these limits the excitement is different for different degrees of rapidity. The slowest visible waves excite the sensation of red, the fastest visible waves excite that of violet, and the colours generally follow the degrees of rapidity in this order : Red, orange, yellow, green, blue, violet.

It is by means of this different perception of the different luminous waves that we are enabled to distinguish colours. Later on I may be able to explain, to a certain extent, the mechanism by which colour is perceived, but the bare facts are enough for the present.

To return to the ether waves. When these are set in motion by a body vibrating very quickly, or, as we generally call it, a self-luminous body, they travel with extreme rapidity in a perfectly straight line until they meet some other body. If this body be transparent, they pursue their course through it, either in the same straight line or with a certain amount of

F 2

deviation, in which latter case they are said to be refracted ; if, on the other hand, the body be opaque, some of them rebound from it, or, as we say, are reflected from its surface. If the surface be smooth, they are reflected in a definite direction; if the surface be rough, they are reflected in all directions. It is by means of these reflected rays that we see those objects that are not self-luminous. Even transparent objects reflect some rays, and it is by these reflected rays that they are seen. In all cases there are some rays which are neither reflected nor refracted, but are absorbed.

It is very instructive to notice the totally different effects produced by the same rays on the nerves of touch and on those of vision. I say the *same* rays, as, although a good many of the heat rays are invisible, yet all the visible rays are, to a certain extent, heating, and some of them, at least, can be recognised as hot by the skin, provided they are concentrated upon it sufficiently.

The difference depends on two causes. In the first place, the optic nerve, however stimulated, gives rise to a totally different sensation to that given by the nerves of touch. The optic nerve can be excited in many ways: by a blow, by a galvanic current, by a rush of blood in its own blood-vessels, or by ether waves of a certain rapidity; but whatever the means employed, any excitement of the optic nerve gives rise in the sensorium to the sensation of light. It can only speak one language, and that language is quite different from the one spoken by the nerves of

touch. In the second place, there is a special and very delicate apparatus by which the optic nerve is enabled to distinguish between ether waves which differ in rapidity, in intensity, or even in direction. There is nothing in the skin which is at all equivalent to this special apparatus, so that the messages given by the skin nerves are very vague and indefinite in comparison with those given by the retina.

It may be as well to give some slight description of this apparatus.

The best way of making it intelligible is to compare it to some instrument which is well known, and of which the mechanism can be readily investigated. We all know what a photographic camera is like : it consists essentially of a dark box with a lens or group of lenses at one end of it, which throws an inverted image of the scene in front of it on to a ground-glass screen, which closes the box at the other end. It is not easy to explain the action of a lens without the aid of diagrams, but it may be sufficient to say that the convex lens, which is the one that is used in a camera, has the property of making all rays that strike on it from a point outside it converge again at a certain distance to a similar point on the other side of it. The result of this is that every point of the natural object to which the camera is turned is reproduced in a similar point on the ground-glass screen, and as the relative position of all these points remains unchanged, the image on the screen, although upside down, is a faithful representation of the object outside— that is, if the screen be at the proper distance from

the lens; at any other distance the image appears blurred. This proper distance is obtained by moving the lens backwards and forwards until the image on the screen appears sharp and clear. The eye is merely a kind of camera, having an arrangement of lenses, which throws an image of the scene outside it on to a sort of screen, called the retina. It also has a mechanism by which sharpness of focus is obtained, but by different means from those employed in the photographic camera. Instead of altering the distance between the lens and the screen, the actual shape of the principal lens is altered, becoming more convex for objects near the eye, and less convex for distant objects. The screen, or retina, that receives the image is formed by the ends of the various fibres of the optic nerve. These fibres end quite differently from the fibres of any other nerve ; they seem to spread out into a uniform layer, composed of minute bodies called the rods and cones—names which roughly describe their appearance. This layer of minute structures forms the essential part of the retina, and it so far answers to the ground-glass plate of the photographic camera that a minute inverted picture of the scene in front of the eye is thrown upon it by the arrangement of lenses with which the eye is provided. The way in which this picture is perceived by the brain remains a mystery, for indeed the transition from the outside world to our own sensations is, in every case, inexplicable; but we must take it roughly that the brain receives a mental picture, which is so far equivalent to the picture on the retina that it is enabled to infer

from it the proper position and luminosity of the objects outside the eye.

But here we are confronted by a special difficulty · we not only see that one object occupies a different position in the field of vision from others, and that it differs from others in intensity of illumination, but it also differs from them in quite another way ; that is, in colour.

Now, this third difference is particularly puzzling, for there is nothing, so far as we know, in the rays of light to account for it.

These rays differ amongst themselves solely in energy (amplitude of swing) and in rapidity of vibration : that is to say, the rays which excite the sensation of green are just the same as those that excite the sensation of red, except that they are vibrating a little more rapidly. Now, the sensation of red is so entirely different from the sensation of green that we should expect some corresponding difference in the ether waves that cause these sensations. What adds to the difficulty is that colours have various peculiarities, to which, again, nothing seems to answer in the physical constitution of light ; for instance, three of the colours, such as red, green and violet, appear to be simple, whilst others, such as yellow, purple and grey, are compounds of two or more of these simple colours. Again, there are some people (called colour-blind) who can see the forms of objects perfectly and some of their colours, but who are insensible to other of the colours—generally to red. In fact, the whole system of colour sensation seems to

be very complicated, whilst the differences in the ether waves are very simple.

This puzzle is so difficult to solve that Helmholtz (the greatest living authority on the subject) acknowledges that he was unable to frame any theory that would in the least account for it, until he met with an entirely satisfactory explanation in the works of Thomas Young, an Englishman, who flourished at the beginning of this century, and to whom is due the glory of having firmly established the undulatory theory of light.

Helmholtz remarks that he was one of the keenest intellects that ever lived, but he had the misfortune to be too much in advance of his contemporaries, so that many of his finest discoveries lay buried in the archives of the Royal Society until they were laboriously re-discovered by a younger generation. Amongst other causes that contributed to the general neglect with which the labours of this great man were treated in his own time must be reckoned a savage and, unfortunately, successful onslaught by Henry Brougham, who afterwards became Lord Chancellor—a man of very inferior capacity to Young, but of infinitely greater pretensions.

The theory of colour in particular had sunk into profound oblivion, until Helmholtz came across it in the course of his omnivorous reading, and was at once struck with the completeness of the solution that it gave to the riddle that had puzzled him so long. Having lent it the authority of his great name (fortunately undimmed by the strictures of any German

chancellor), it is now almost universally accepted by the scientific world.

As this theory is of great importance to the artist, I will do my best to expound it. Since the time of Newton it has always been held that there are only three simple or primary colours, and that all the others are merely mixtures of these simple colours. According to Newton, the three primary colours are red, yellow, and blue. He seems to have arrived at this result chiefly by experiments on the mixture of pigments. But unfortunately, the mixture of pigments is a very different thing from the mixture of light of different colours. There are many ways of producing a true mixture of coloured lights ; perhaps the simplest is by using what is called a colour top. We slip on to an ordinary top little discs of cardboard. By painting half the disc of one colour and the other half of another, and then making it spin round, we see nothing but an uniform tint, which is the true mixture of the two colours. If we try a mixture of blue and yellow in this way, we get not green, but a kind of grey. By experiments conducted in this and similar ways we have now found out that the true primaries are red, green, and violet, by a mixture of which all the other colours can be produced. Yellow is formed by a combination of red and green, blue by a combination of green and violet, and purple by a combination of violet and red. These are the so-called secondary colours. By mixing all three primaries together in certain proportions we get white or grey. By mixing the three primaries in

other proportions, we get the so-called tertiaries, such as russet, olive, &c.

It may startle those who are only accustomed to the mixture of pigments to hear that blue and yellow light do not produce green, but grey or white, according to the intensity of the illumination. That this is so can be readily proved by the experiment mentioned above and by many others. But why do blue and yellow paint produce green? To answer this we must explain how it is that pigments produce their different colour-effects—they do so by absorbing certain colours from the white light that reaches them, whilst the colours that remain unabsorbed are reflected back to the eye, and produce the special colour-effect of the pigment.

The question of the mixture of pigments is very much complicated by the fact that none of the pigments in use represent any pure colour. When examined by the spectroscope they are found to reflect light of many different colours, their whole effect being the average of these different hues. Now, take the case of a blue pigment such as cobalt. The blue paint absorbs most of the red, orange and yellow waves, reflecting back to the eye the green, blue, and violet, so that the result is a general impression of blue. Again, take a yellow pigment, which absorbs the blue and violet waves, reflecting back the red, yellow, and green. A mixture of these two will absorb, more or less, every colour except green, which will be, therefore, the dominant tint of the mixture.

It must here be remarked that colours differ from

one another in three quite distinct ways. Firstly, in tint—*i.e.,* all shades and varieties of red are different from all shades and varieties of green. Secondly, in luminosity—a light red is different from a dark red. Thirdly, in what is called saturation—that is, one red can be much more red than another, quite independently of its luminosity. When we speak of a full, rich, intense tint, we mean what, in scientific language, is called a saturated colour. So that to properly define a colour, we must bear these three qualities in mind. Take any given colour, such as the hue of a primrose. In the first place it is yellow, in the second place it is light, in the third place it is not very saturated : that is, the hue is a light yellow of but slight intensity.

It will be seen from all this that the whole system of colour, as we perceive it, is a very complicated affair ; but, as I have already pointed out, there are no such complicated differences in the ether waves, which undoubtedly give rise to the sensations of colour. *They* only differ in rapidity and in intensity. There is absolutely nothing that corresponds to the difference between the primaries and the secondaries. Nor can we understand, from a consideration of the properties of the ether waves, how it is that one colour should differ from another not only in degree, but absolutely in kind. The cause of these complications must be sought for, not in the physical properties of light itself, but in the instrument which perceives it. In the same way that ether waves which are physically identical give rise to the quite

different sensations of heat or light, according as they stimulate the skin nerves or the optic nerve—so are also the waves which strike the retina perceived in different ways, according to the different structure of the apparatus which they affect. Young's theory is briefly this : that the retina is supplied with three different kinds of nerve-fibres. The one kind is chiefly stimulated by the longer light waves, and, when stimulated, gives rise to the sensation of red ; another responds to the light waves of middling length, and gives rise to the sensation of green ; the third responds to the shortest visible waves, and gives rise to the sensation of violet.

We have said that each kind is chiefly stimulated by the shock of waves of a certain length, but they also respond in a lesser degree to all the visible waves. For instance, the red-seeing fibres are chiefly excited by the longest visible waves, but they also respond somewhat to the shorter ones, whilst the green-seeing fibres not only respond to the waves of middling length, but are also slightly affected by the longer and shorter waves. So that waves of an intermediate length can excite equally two sets of nerves.

When two sets of nerves are excited, either by these intermediate waves or by a mixture of waves of different lengths, one of the secondary or mixed colours is perceived. When all three are equally excited, we have the sensation of white or grey, according to the intensity of the excitement. When they are unequally excited, we perceive one of the tertiary colours,

Simple as this theory is, it is, nevertheless, capable of explaining most of the puzzling anomalies of colour sensation.

For instance, take the curious defect called colour-blindness. A colour-blind man has, apparently, perfeet vision for form, and light and shade; he can also distinguish some colours quite correctly, whereas others he mixes up in the most hopeless manner. As a general rule, the reds are the stumbling-block of the colour-blind. A full rich scarlet appears to them almost black, as is evidenced by the well-known story of the Scotch minister, who selected a brilliant scarlet cloth for his coat under the impression that it was a nice quiet colour. Such people can see blues, greens, and violets very well, but a bluish-green generally appears to them nearly colourless. So that they cannot distinguish between the leaves and the flower of a scarlet geranium, nor between the red and green lights used on railways—which latter is a matter of considerable practical importance The colour of these objects would appear to them the same ; they would only differ in luminosity.

Young's theory gives a very complete explanation of these peculiarities. We have only to suppose that the particular nerve-fibres which respond to the stimulus of the longer waves are absent or paralysed, and we at once have a sufficient cause for the non-perception of red. The green and violet-seeing fibres would be in full operation, and these would be amply sufficient for the perception of form, and light and shade, except that all red objects would appear too dark and

quite colourless. If the green and violet-seeing fibres
were simultaneously excited, as they would be by
light of a green-blue tinge, the sensation of white or
grey would be produced, exactly as in the normal
eye the sensation of white is produced by the simul-
taneous excitement of all three sets of fibres.

This is the ordinary form of colour-blindness. In
some rare cases one of the other sets of nerves seems
to be deficient, thus giving additional confirmation to
our theory.

It will be observed that as light of any definite
wave-length not only excites its own proper set of
nerves, but also to a much less degree the other two
sets, it follows that all our colour sensations must be
a little mixed : that is, we cannot see red without some
slight admixture of green and violet, nor can we see
green without · some slight admixture of red and
violet, and so on. That is, under ordinary circum-
stances we never get a quite pure colour-sensation.
Here, again, the theory is strikingly confirmed ; but to
show in what way, we must refer to a very curious set
of phenomena which we have not yet touched upon.
Nerves, like muscles, are easily fatigued; the stronger
the stimulus the greater the subsequent exhaustion.
To this rule the nerves of the eye are no exception.
After we have been out of doors in strong sunshine
for some little time, the retina loses all power of re-
sponding to a moderate amount of light, so that if
from the sunlight we step into a dark, feebly-lighted
room at first we can see nothing. The retina is too
tired to respond to a feeble stimulus, but in a very

short time it recovers from its fatigue, and every object in the dark room becomes visible. But not only can the whole retina become fatigued, separate parts of it can also be temporarily paralysed. If we look at some small light object on a dark ground for some time, without letting the gaze wander, and then look away on to some grey, moderately lighted expanse, we shall see an image of the former scene, with the light and shade reversed—that is, the light object will appear dark, whereas the dark background will appear light, like a photographic negative.

The explanation of this appearance lies entirely in local fatigue of the retina ; the part which received the image of the bright object has been so worn out by the over-stimulus that it cannot respond to the moderate light received from the grey expanse at which it is now looking, so that a dark spot is perceived corresponding in shape and area to the fatigued part of the retina. The rest of the retina, however, has been rested by looking at the dark background, so that when the gaze is turned away the moderate light it now receives is sufficient to excite it strongly. It is obvious that for the success of this experiment it is necessary that the eye should be steadily fixed upon the bright object, otherwise if the gaze be allowed to wander, successive portions of the retina will be fatigued in turn. It is not advisable that the light object should be too bright, white paper is quite bright enough. A brighter object produces so much excitement on the retina that a different

series of effects are produced; besides, too great a stimulus can be very injurious.

But not only can separate portions of the retina be excited, but also separate nerve-elements, so that it is quite possible to fatigue the red-seeing nerves (for instance) without the others.

If we look for some time fixedly at a bright red object and then transfer our gaze to a piece of grey paper we shall see a blue-green image of the object. The explanation of this is that the red-seeing nerves of one part of the retina have been temporarily paralysed by fatigue, so that the light coming from the grey paper, which, under ordinary circumstances, would stimulate equally all three sets of nerves, has a much greater effect on the green and violet-seeing fibres than on the others, so that the predominant perception in this part of the retina is of a greenish-blue.

This suggests to us a means by which we can see colours in a much purer state than we can ever do under ordinary conditions. Our ordinary perception of the strongest red is mixed with sensations of green and violet—chiefly of green, as the longest waves have the least effect upon the violet-seeing nerves.

If we can in any way paralyse these two sets of nerves, we shall be able to have an almost pure sensation of red.

To achieve this object we look at that portion of a solar spectrum where the green fades into the blue. After gazing at it steadily for some time we turn our gaze to the red end of the spectrum, and perceive

a red such as we have never seen before, for it is now, for the first time, unmixed with green and violet.

All these curious phenomena and many others are perfectly explained by the Young theory of colour, and no other theory gives anything like a rational explanation of them ; so we need not scruple to adopt it as true, at any rate in its main outlines, although anatomical research has not as yet confirmed its fundamental assumption—that of the three nerve-fibres. But even here some slight confirmation is not wanting, for in reptiles and birds, though not in mammals, some traces have been found of the requisite differences in the retinal elements.

I trust that in this brief sketch I have given some slight idea of this beautiful theory. I must refer those who would like to make a further acquaintance with it either to Helmholtz's great work, the " Physiologische Optik," or, if they are unacquainted with German, to two papers in his popular scientific lectures, which have all been translated into English. There is also an excellent work on the subject in the International Scientific Series, " Modern Chromatics," by Professor Rood.

Hitherto we have been concerned with the apparatus which perceives colour, we will now consider the question in its more general aspect—that is, the differences in natural objects which make them appear to us of different colours. These differences are solely differences of wave-length. Objects which send to us ether waves of a certain length appear to us red, others which send shorter waves appear to us green,

G

and so on. If an object send to us, as is nearly always the case, a number of waves of different lengths, then the colour-sensation depends on the average effect produced by all the different waves.

Our usual source of light (except in London) is the sun. Sun-light may be said, roughly speaking, to be composed of all the visible waves in such proportions that it produces the sensation of white.

Ordinary daylight, when direct sunlight is not visible, is simply sunlight reflected either from the minute water-globules which constitute clouds, or else from the still more minute particles which we perceive as the blue sky. It also produces the general sensation of white, although usually a white that is colder or more inclined to blue than sunlight. The sun's light, or this reflected daylight, or the light of any self-luminous body, is also reflected from all natural objects, and it is in this way that we see them. But as a general rule it is not reflected in the same proportions in which it is received. Nearly all coloured objects owe their colours to the fact that they only reflect some of the waves of light, absorbing or transmitting the others. So that the selected waves that are reflected from them do not excite the three nerve-elements equally, and, as we have seen, any unequal excitation of the retinal elements gives rise to the sensation of colour. Our artists' pigments are bodies which have this property of absorbing some of the rays of light and reflecting others. Our white paint absorbs very few rays and absorbs these equally, so that light is reflected from it practically unchanged.

Our red pigment absorbs many more rays, chiefly of the shorter kind, so that the ones it reflects are mostly the longer ones. Our blues, on the other hand, absorb mostly the longer waves, and so on. A black pigment is one of great absorbent power, so that very few rays are reflected from it.

We are now in a position to understand how it is that an arrangement of differently-coloured pigments on a canvas can so thoroughly represent a natural scene. To our eyes a natural scene is nothing more than a pattern of colours produced by the varying absorption and illumination of natural objects. Our painted canvas can give just the same absorption of colours, and can represent the varying illumination by pigments which reflect more or less light to the eye.

But here comes a difficulty. Can it represent the same intensity of light and shade that the natural scene gives? In many instances it certainly cannot. Let us take the case of a picture representing a sunlit landscape. We will suppose it hangs on the wall of a room. It is obvious that its highest light is only white paint illuminated by the moderate light that enters an ordinary room. This must surely be many times darker than, say, a white stone, on which the sunlight falls in the real landscape—and yet it certainly looks like sunlight. To bring out the difficulty more clearly, we will suppose that there hangs side by side with this picture another representing a moon-lit scene.

In this also a white object would be represented by white paint, with perhaps a slightly bluish tinge.

G 2

At any rate, the two white objects in the two pictures would be represented as of almost equal luminosity, and yet we know that sunlight is many times more powerful than moonlight. Indeed, it is much more so than we think. According to Wollaston, who made direct photometrical observations, sunlight is about 800,000 times stronger than moonlight. And yet in our pictures we paint them almost of equal strength! The very surprise with which we hear of this enormous difference puts us on the track of the solution of the puzzle. As a matter of fact, we are in the habit of disregarding differences of total illumination. What is important to us is to know the constant unvarying qualities of bodies, not their accidental differences which vary from one moment to another. To distinguish one object from another it is very important to know their relative colours and luminosities; that is, that under any illumination a red object is redder than a blue one, and a white object is lighter than a black one. This tells us something of importance, and enables us to recognise different bodies under all sorts of circumstances; but that a sheet of white paper is so many thousand times lighter in sunlight than in moonlight, is of no importance to us whatever under ordinary circumstances, so we habitually disregard it. And this is not only a matter of habit, but it is a necessary consequence of the structure of our eyes.

As we have said, the retina gets very easily fatigued, and in this state only responds to stimuli of great intensity; whereas in a condition of rest it is

easily excited by very faint stimuli. For instance, we go out of doors into the full sunlight. At first everything seems one blinding glare, but in a very short time the retina gets dulled, and is no more conscious of any excess of light. The lights are no longer blinding, and the shadows seem strong and dark, although the shadows of a sunlit landscape are generally much brighter than any light inside a room, unless the sunlight enters it. If we now leave the sunshine and go into some dimly-lighted room, a contrary effect is produced, to which we have already alluded. At first the tired retina refuses to respond to the feeble stimuli given by the objects in the room, and everything seems dark ; but in a very short time the retina recovers, and any light object shines out with an intensity that seems quite brilliant to the rested eye. So that not only do we disregard great differences of illumination as being unimportant to us, but also the structure of our eye prevents us from truly perceiving them.

We will now go back to our two landscapes. The white in the sunny picture strikes upon an eye that has not been dulled by exposure to the sunlight, so that its want of real illumination is compensated by the increased acuteness of the retina. But this acuteness is not nearly so great as it would be if the eye had only been exposed to the much feebler light of the moon. So that the moonlit landscape, striking upon a comparatively inert eye, does hardly seem brighter than the actual scene would seem to the highly sensitive eye, that would naturally behold it.

But if both the landscapes are equally luminous, how is it that we can see at once that one is meant for moonlight and the other for sunlight?

The answer to this is very interesting.

In the first place it is only the brightest objects of both that we paint with our strongest light. In the sunny landscape we paint all the objects that are moderately illuminated almost as bright as the highest light, reserving our darks only for the few really deep shadows. In the other it is only the very brightest objects that we paint bright at all. The moderately illuminated ones are all merged in the shadows. And this corresponds to a real difference in our perceptions of intense and slight illuminations. In a sunlit scene all objects that are not actually in shadow seem almost equally bright. In a moonlit scene all objects, except the brightest, seem almost equally dark.

There is another difference of almost equal importance. The general colour of the sunny landscape will be warm—that is, inclined to the reds and yellows—whereas the general colour of the other will be cold—that is, inclined towards blue and violet—and this will be the case even when they represent the same scene. The difference of colour will, at once, suggest the difference of illumination. And yet moonlight is merely reflected sunlight. How can we account for its looking so much colder ?

Here we must have recourse to Young's theory. It would seem that the three sets of nerves do not respond quite equally to light of different intensities. That is, white light of great intensity has most effect

on the red-seeing nerves and least on the violet-seeing ones, so that sunlight appears to us of a slightly orange tone, whereas white light of feeble intensity has most effect on the violet-seeing nerves and least on the red, so that moonlight, although it sends to us light of the same average wave-length as sunlight, appears to us of a bluish tinge.

There is a simple experiment which brings this out clearly: If we take two pieces of paper, and colour one of them red and the other blue, so that in a room they appear of the same brightness, and then take them out into the sunlight, the red will appear lighter than the other. By moonlight the blue will appear much lighter than the red.

It is chiefly by paying attention to these two principles that our two landscapes look right in spite of their falsity of illumination.

The latter principle will explain how it is that a landscape, which is painted out of doors, is apt to look cold when it is brought indoors. It should always be recollected that, other things being equal, the stronger the illumination the warmer the picture will look.

There is a very important practical lesson which can be drawn from the ready adjustment of the retina to different degrees of illumination. It is well known that one of the great difficulties in painting is to get *breadth* (as it is called); that is, to avoid bringing out too clearly unimportant details. As we say, we see too much. We have to learn not to paint all we see. It is not generally known that the cause of this

difficulty is not so much mental as physical. We really do see more when we look for some time at each separate detail than when we look at the scene as a whole, and this is not so much a result of increased attention as of adjustment of the retina to the particular degree of light given out by each separate part of the scene. For instance, we are looking at a sunlit landscape, in the foreground of which is a white stone, which is the brightest object of the scene. When we look at the view as a whole, the stone merely appears to us as a mass of dazzling white; but if we fix our gaze upon the stone, in a very short time it ceases to dazzle us, and we are able to see all sorts of little markings and varieties of tint upon it. The retina has become dulled to just the proper degree at which it can best see the stone. But should the painter represent it with all these markings? Certainly not, for his object is to represent the scene as it appears to a casual spectator—that is, he must paint his stone as he sees it when he first glances at it, not as it appears when he has been gazing at it for some time. Again, if he have in the same landscape to paint a log of wood lying in the shade: when he looks at it with his eye dimmed with the general sunlight it appears simply a brown mass, but, after gazing at the shade for some little time (as he will have to do if he wish to paint it), his eye will become rested, and will see all sorts of detail in the log, which he must resolutely refuse to paint.

This constitutes a very real difficulty, for it obliges us to run counter to the most wholesome

instinct that an artist can have—viz., to paint what he sees. It applies also, though in a less degree, to objects painted in a studio light. The best practical way to get over the difficulty is never to keep the eyes fixed for long on the detail that one is painting, but to continually look away and endeavour to get a true idea of the scene as a whole.

We are now in a better position to examine the question of how far a picture can truthfully represent a natural scene. Even from the slight sketch I have given of the theory of vision, it is abundantly evident that in all essentials the impression received on the retina from a picture can be identical with the impression received from the scene that it depicts.

Here, however, the question suggests itself, how is it that we know at once the difference between a picture and the reality? I have little doubt that, as a rule, we know a picture to be a picture, because it is hanging up on a wall or standing on an easel, or, at any rate, visibly disconnected from the scene around it. Indeed, under certain circumstances, it can very well be mistaken for the reality.

If a glimpse be caught of a portrait in a possible place for a person to be in, it can very well be taken (at any rate, at first sight) for a living being. This especially holds good in the case of a portrait seen in a looking - glass, and particularly if only a small piece of it be seen, for in a looking-glass we are accustomed to see a bit of a person cut off from all its surroundings.

There is a story that Philip **IV.** of Spain came

into the studio of Velasquez, and seeing there a portrait of a certain admiral, believed it to be the admiral himself, and rated him soundly for being at Madrid at a time when his duties were far away. Of course this story may be untrue, especially as it is a matter of history, but it is not in any way impossible.

Again, I recollect noticing myself that in the celebrated panorama of the Siege of Paris, exhibited in the Champs Elysées, that it was very difficult to see where the earthworks, which were actually built up round the spectator, and on which real objects were strewn about, merged into the painted background. In one place there were two cannons, side by side—one was real and the other was painted—and, at first sight, both looked equally real.

But we must not carry this too far ; the possibility of actual deception only exists in the case of large pictures seen at a considerable distance. When pictures are looked at more closely there is a definite discrepancy between them and solid objects which is quite sufficient to enable us at once to distinguish them from any real scene. But even this difference does not exist for people who have only one eye.

It is quite obvious that in viewing solid objects we get slightly different views of them with each eye. And yet, unless under exceptional circumstances (such as an extra glass of wine or two at dinner), we never see these two views, but have a single impression of the scene. Now, it is difficult to understand how two different views can be so blended as to make

a single picture. The way the eyes get over the difficulty is this :—They select some particular part of the scene in front of them, and turn towards it in such a way that it is thrown on precisely the same spot in both retinas—the spot where the acutest vision resides. In this way the brain receives a precisely similar message about this part of the scene, and it is easy to understand that these two identical messages are perceived as one and the same ; but all the rest of the scene is slightly different in each eye. How is it that this difference is not perceived? The answer is simply that we do not pay any attention to it. We *see* the rest of the scene double, but our attention is so much fixed on the one part of it that we see single, that we merely get a general impression of the rest. As a matter of fact, the act of seeing consists in making our eyes converge with great rapidity, first on one part and then on another of the scene we are looking at, so that we see distinctly every detail in turn. It is in this way that we get a distinct picture of the whole scene.

It is a very curious fact that although we are continually *seeing* these double images, yet we never know that we see them until our attention is specially called to them, and even then we are made aware of them with difficulty—which is another proof of the extent to which we disregard all that is unimportant to us in the act of seeing.

The best way to perceive these double images is to hold up a finger about a foot in front of the nose, and then to look at a candle some little way off.

When we look at the candle we distinctly see two fingers. When we look at the fingers we see two candles.

Now, when we look at a picture, nothing of this kind takes place. If we fix our gaze on an object in the foreground of the picture we do not see the background double, and *vice versâ*, as we should do in the real scene. Nor do we see two different views of the same object—in fact, the image of the whole picture is practically identical for the two eyes; and this is quite enough to prevent our taking it for a real scene —unless it be some way off, for at a certain distance, even in a' real scene, the image in each eye is practically identical.

But there is more than this in the matter. In order to make the two eyes converge on any given point, we have to exert the muscles that move the eye. This convergence is effected by a little muscle at the inner corner of each eye which rolls the eye towards the nose. When we make the eyes converge on near objects we obviously have to exert these muscles more than when they converge on distant ones, and the varying sensation of this muscular strain is undoubtedly important in making us aware of the relative distances of different objects. Of course this method of discrimination fails in the case of pictures.

Every part of a picture is, roughly speaking, at the same distance from the eyes, so the strain of convergence is the same whether we look at the fore ground or at the distance. But this also does not affect pictures seen some way off, for the difference of

convergence required for an object thirty feet off and one a thousand miles away is practically imperceptible.

Even in the case of pictures seen closely, these discrepancies are very small, certainly not great enough to prevent a picture being optically almost identical with its subject, although they are sufficient to destroy any possible illusion on the part of the spectator. How small the discrepancies are may be readily seen from the fact that they do not affect one-eyed people. But there are other slight differences which also apply to their case, and which we will mention for the sake of completeness, although they are of no practical consequence to the painter.

Besides the larger movements of convergence which are required when we look from a distant to a near object, there is the much smaller movement of accommodation, as it is called, by which the principal lens of each eye is made more convex in order to bring the nearer object to a sharp focus on the retina. In fact, with all people of good sight, the shape of the lens is continually changing with the varying distance of the object looked at, and this change of shape is produced by a muscular effort; but we are so little conscious of this effort, and it seems to play so small a part in our recognition of different distances, that it may be dismissed as unimportant to our present purpose. Of course in looking at a picture this adjustment is not required, but it is very improbable that we are conscious of the difference.

Again, there is the discrepancy in the illumination

of a picture as compared with that of the real scene, but we have already shown that even in extreme cases the discrepancy is unimportant, though sufficient to prevent any actual illusion, and in many cases (such as pictures which are supposed to represent a quiet indoor light) it hardly exists.

There is one other reason why we so seldom take a picture for a reality which does not affect the actual truthfulness of the representation. When we move about in front of a real scene, the different objects which compose it take up different positions with regard to one another. The whole scene changes as we change our point of view. We have an extreme instance of this when we look out of the window of a rapidly moving train. The near objects seem flying past us in a direction contrary to our motion, whilst the distance in contrast to them seems to be moving with us. Now, any movement, however small, produces this effect to a certain extent. But when we shift our position in front of a picture, nothing of the kind takes place. The picture can become foreshortened as a whole—that is, all the objects represented in it may seem a little narrower in proportion to their height—but they do not change their relative positions. If an object is fronting us in the picture it will remain fronting us, however much we move to one side. If an object is partly behind another in the picture we cannot see more of it, however much we peer round the corner.

These considerations may, perhaps, explain a very simple mystery, that has cast an undeserved glamour

round the art of the portrait-painter. I have often
heard it remarked (sometimes in a tone of awe) of
such and such a portrait, that the eyes of it follow
you all over the room.

A very little consideration will show that if the
eyes in a portrait look at the spectator when he is in
front of it, they must continue to look straight at him,
however much he may change his position. No one
expects to find that a portrait, which is full face in
one position, becomes three-quarter face in another,
and yet people are surprised to find that the eyes
follow the same rule.

As I have remarked, this discrepancy, although
generally sufficient to show the unreality of a picture
(as few people look at anything long without changing
their positions), cannot be said to militate against the
possible truthfulness of a picture, which is always
supposed to be looked at from one point of view.

This, I think, exhausts the list of necessary dis-
crepancies between pictures and the scenes that they
represent. The distinctions are, obviously, of no
great importance, and certainly cannot in any way
justify the theory that it is impossible to give anything
like a true representation of nature. It is certainly
difficult to produce an actual illusion, but then the
smallest crack or flaw in the surface of a looking-
glass is sufficient to tell us that we are looking on a
reflecting surface and not on a real scene ; but this
would surely not prevent the reflection from being
absolutely like the image which produces it.

Similar considerations apply in the case of a

picture, the essential truth of which is not in the least affected by the trifling peculiarities which distinguish from the reality. So that we can take it broadly that there is nothing to prevent our picture giving to the eye essentially the same impression that an actual scene gives.

I have been obliged to insist on this rather strongly, as a great deal of nonsense has been talked about the impossibility of reproducing nature; from which it has been deduced that the true function of the artist is to translate natural objects into something totally different, it being a hopeless task to endeavour to represent them faithfully. Now, of course, such a translation may be very interesting, especially to those who are chiefly concerned in watching the workings of artists' minds, but a direct and faithful representation is perfectly possible, and should, to my judgment, be the one thing to be aimed at by the student.

But although this representation is possible, it is by no means easy, and it is rather puzzling to explain in what the difficulty consists.

To state again the problem that is before the student: Whenever we look at a scene we have a patchwork of forms and colours floating before our eyes, and this is in fact the scene. We have to place on canvas similar patches—similar in form, position, and intensity. That is all. Now, why is it so difficult? The crux of the matter lies in this: that we have learnt to see in nature so much more than this patchwork of forms and colours which is all that is

impressed on the retina. We ourselves put into a scene much more than we actually get from it. We say that we see that an object is solid, that it is hard, that it is a long way off, &c. Now, we *see* none of these things ; we only infer them.

Our knowledge of form and distance is gained chiefly by touch. We cannot possibly tell the real shape of objects merely by looking at them, as the appearance of them varies with every new point of view that we take up. It is by the association of certain visual images with certain definite sensations of touch that we are enabled to have an idea of what we call the form of a thing—that is, of the permanent characters which distinguish it from other things, and of which the continually varying visual images are merely symbols.

This is, in fact, what we want to get out of vision. We want definite information as to the more or less permanent characters of things that surround us. We make use of our visual impressions for this purpose, but pay no attention to what they are like in themselves. It is very much what happens when we hear a person talk: we concern ourselves not at all with the separate sounds as they reach our ear; we merely use them to gain a knowledge of what is passing in another man's mind—a subject that is quite out of the domain of acoustics.

Here we have the great difficulty : we persistently use our eyes for entirely different purposes to those pursued by the artist, until at last we lose our faculty of seeing pure and simple, and the artist has to

H

struggle all his life to disentangle his vision from all the things his intellect has put into it, and never quite succeeds at the best.

That is the problem. To see the world as a new-born infant sees it—an object so difficult of attainment that we have to seek for help wherever we can find it.

A very remarkable instance of the difficulty we have in seeing things as they really appear, and also of the way that theory can help us out of these difficulties, is afforded by aërial perspective.

If we put aside the stereoscopic effect of the combined use of both our eyes, we judge of distance in two quite different ways. In the first place, objects diminish in size the further off they are; in the second place, they alter in colour and in light and shade. These effects can be, to a certain extent, reduced to rule, the former kind being the subject of ordinary perspective and the latter of aërial perspective. Now, these rules are particularly valuable to the artist, as there is nothing in which the judgment is more apt to falsify the visual impression than in these effects of distance.

The reason of these errors of judgment undoubtedly lies in the principle we have before mentioned, viz., that we use our eyes for the practical purpose of distinguishing one object from another, and for this purpose we have to disregard, as much as possible, the varying appearances of the same object.

As a rule we think of an object as we see it under

the most favourable circumstances for bringing out its peculiarities, viz., near to us, in a good light, and in such a position that we see its form most plainly. This is, to us, what the object is really like. If we happen to see it very much foreshortened we disregard this foreshortening as much as possible, and so far do we carry this that we actually imagine we see it less foreshortened than it is. This is why the drawing of anything that is foreshortened is so very difficult. In itself there is no more difficulty in drawing an object in one position than in another. In every case the object forms a mass of a certain definite outline, which is very often less complicated in the foreshortened form than in the other, yet when we come to draw this outline we inevitably modify it in accordance with our conception of what the object ought to look like.

For instance, if a beginner has to draw the top of a square table, he will inevitably draw it squarer than it really appears to him, because his idea of the table is a square, although he very likely has never seen it as such. Again, if you set a child to draw a carriage, even if he has one in front of him to draw from, he will certainly make the further wheels as large, or nearly so, as the near ones. He knows they are really the same size, and this makes him think that he sees them so. It is to correct errors of this kind that ordinary perspective is so valuable. It is no part of my present purpose to enter further into this subject. I have merely endeavoured to show why it is so necessary to learn it.

H 2

A very similar difficulty occurs in the case of
aërial perspective. We always think of objects as
they appear to us in their most distinctive colours—
that is, near to us and in a full light. It is extra-
ordinary how this conception misleads us when we
look at distant objects. It requires long training
before we can recognise the colours in which they
really appear. And yet the colour sensation is there
if we could only pay attention to it, and not confuse
it by our ideas of what the colour ought to be. For
instance, anyone not an artist, if asked what was the
colour of a clump of dark trees on a distant mountain,
would inevitably answer " dark green," which is the
colour he would expect the trees to look if he were
close to them ; and yet the visual impression
they make on his retina is that of a pale blue-
grey. That is how he really sees them ; but it would
take him years of training before he became aware
of it. Here the science of aërial perspective steps
in to help us recover the lost *naïveté* of our visual
impressions. As we have such a tendency to falsify
our impressions we must be helped by rules which
tell us what we really see.

The subject is a difficult one, and it is only quite
of late years that it has been put upon a firm
basis.

In most treatises on painting, if any rules of aërial
perspective be given, they are generally quite false
and entirely inconsistent with the practice of artists.
One continually finds such idiotic statements as :—
" the effect of atmosphere on colours is to make

them bluer," quite regardless of the fact that the sun never looks blue, and the longer the stretch of atmosphere that it is seen through (as at sunrise or sunset) the further away from blue it gets.

To arrive at the true theory we must again refer to the nature of light.

The ether waves, which are the physical side of light, vary as we have seen in amplitude of swing. Now, this is only another way of saying that some of the waves are bigger than others. Of the visible waves the red are the biggest, the violet are the smallest. Now let us transfer our thoughts to the seashore. We will suppose it is a rocky coast, with great boulders strewn amongst the surf. If we watch the waves as they come rolling in, we shall see that a big wave sweeps right past a boulder which is large enough to turn back a little wave, and to scatter it in all directions. Now, in spite of their small size, the same thing happens in the case of the ether waves. If only we have obstacles small enough, a selective influence is exerted, the little waves are turned back and scattered in all directions, whilst the big waves pass on almost undisturbed. Now, our atmosphere is strewn with little particles, which are quite small enough to produce this selective effect—tiny portions of organic or inorganic dust with minute watery globules. It is these that render our atmosphere visible—in itself air is a colourless gas. Now, let us consider a little the precise effect of these particles. As the light streams to us from the sun it has to run the gauntlet of all these little obstacles, with the

result that a much larger proportion of the big red and yellow rays reach our eyes than of the little blue and violet ones. If the extent of dust-laden air is not too great, as at mid-day, when the sun's rays come more or less direct to earth, the resultant light is white ; but then there is little doubt that the sun itself is blue—that is, it would appear blue to us could we see it without its being modified by our atmosphere. But as the excess of blue rays get filtered out before the light reaches us, the impression that we get is white of a warmish tinge—a white that can become blood-red at sunset, when the sun's rays have to reach us through a vast expanse of the heavily dust-laden air that is close to the earth's surface.

But what becomes of the blue and violet rays ? They are dispersed in all directions by these tiny obstacles, many of them flying off into space ; but some of them, after many different reflections, finally find their way to us by a more or less roundabout path. It is these rays that constitute the blue of the sky. They are the smaller visible waves, filtered out from the sunlight that reaches us directly, and restored to us in part by the very particles that have stopped them and dispersed them.

This filtering effect applies, of course, not only to the direct light of the sun but also to any light that reaches us, whether from a self-luminous body or whether it be reflected sunlight.

Take the case of a distant mountain covered here with patches of snow, there with dark pine forests. The light that reaches us from the patches of snow

will be chiefly reflected sunlight. As the light is powerful it will reach us almost unchanged by the stratum of air in between; should the mountain be very distant, and the air heavily dust-laden, the snow will assume a warm tinge, owing to the smaller waves being filtered out and dispersed; but this tendency is partly counteracted by the blue light which reaches us reflected from the particles themselves—in fact, the air between us and the mountain is a part of the blue sky, and naturally sends blue light to us; but if the light from the snow is very powerful this blue light is overpowered, and the general tone is warm. The dark forests, on the other hand, send very little light to us, so that we get, almost unchanged, the blue light of the atmosphere between us and the forests, so that instead of the dark green of the pine trees what we really see is the light grey-blue of the atmosphere.

In the same way any patches of rock on the mountain which are lighter than the air between them and us will appear of a slightly warmer tone than if they were close at hand; whereas dark patches of rock will appear of the colour of the atmosphere.

The light, in fact, that reaches us from any distant object is the result of a sort of give and take between it and the atmosphere. The light that it sends to us is made warmer or more orange by being deprived of its blue rays; but then the atmosphere itself sends us a blue light which conflicts with this warm tone. If the object is lighter than the atmosphere, the result of this exchange is either to leave its colour almost

unaltered or else to make it warmer ; no light object is ever made bluer by distance.

If the object is darker than the atmosphere the atmospheric tint prevails, and its colour becomes lighter and bluer. The colour of very dark objects at a considerable distance is entirely replaced by the atmospheric colour, so that all dark objects at a distance have a tendency to assume a light grey-blue tone.

So that the whole effect of our distant mountain is that the patches of light upon it tell out strongly with all their differences of colour clearly marked, although with a tendency to an extra warmth of hue; whilst the shadows and the dark patches generally are of an almost uniform tone of grey-blue—all local differences of colour being obliterated by the atmospheric tints between them and the spectator.

Such is, briefly, the rule of aërial perspective. The effect of distance is to leave lights warmer or unchanged. Darks all tend to a uniform light grey-blue. Once this truth is recognised, the eye can be rapidly trained to see the colours of distance as they really appear. The painter will never be safe until this is done, for no amount of theory can supply the want of immediate perception. But the theory can undoubtedly aid the perception, and can, to a certain extent, supplement its shortcomings.

But we have not done yet with the action of minute particles on light. What we see on a very grand scale in the atmosphere obtains also in a much lesser degree in artists' pigments. These consist of

very minute particles, floating about in a more or less colourless medium—*i.e.*, the oil in which they are ground. Now, these minute particles exercise a selective effect on light, solely by reason of their minuteness, and quite independently of the proper colour of the pigment they compose. The pigment in itself absorbs certain rays of light, reflects others, and transmits others. If the coat of paint be sufficiently thick and opaque it will hardly transmit any rays at all. We then get the true colour of the pigment—that is, simply the rays that it reflects; but if the coat of paint be thin and transparent it is naturally modified by the ground on which it is laid shining through it. At first sight the effect of this would seem to be very simple. A white ground, such as the ordinary surface of a canvas, shining through a thin coat of pigment, would naturally be supposed to make the pigment appear whiter, whilst a black ground would make it blacker, and, generally, a ground of any particular colour would simply mix its own tint with that of the overlaid pigment.

But in practice this is found not to be the case— not, at least, with the simplicity and completeness that we should expect.

For instance, if we smear a little yellow ochre lightly over a white ground, so that it appears more or less transparent, the resultant colour is more orange than the proper hue of yellow ochre. Again, if we rub it lightly over a black ground we get a much colder tint. It assumes a slightly greenish hue.

The effect is, perhaps, most marked with black pigments. If we mix ivory-black with flake-white we have a neutral grey. If, instead of mixing it with a white pigment, we rub it lightly over a white ground, so that the ground shows through, we obtain a decided brown ; whereas, if we take the neutral grey produced by the mixture with flake-white and rub it lightly over a black ground, we do not obtain merely a darker grey but a grey that is of a decidedly bluish tinge. And, generally, we can say of all pigments, that when a ground lighter than themselves is seen through them, then the resultant tint inclines towards warmth; whereas if the ground be darker than themselves, the resultant colour inclines towards coldness —warm and cold, as applied to colours, meaning here, as elsewhere, nearer the red and nearer the violet ends of the spectrum respectively.

Of course the effect of this is very slight, but it is distinctly perceptible, and has to be carefully borne in mind in all oil-painting. Only by painting thickly can we be sure that any tint we have mixed will remain unchanged when we put it on the canvas. A thin coat of paint will be warmer or colder than its true tint, according as it is put over a light or a dark ground.

So different are the effects of a thin coat of paint on a light and a dark ground respectively that artists apply two different names to these operations. A thin coat of paint over a ground lighter than itself is called a glaze, but over a ground darker than itself is called a scumble. A glaze nearly always gives

richness and warmth, whereas scumbling is used to give cold grey tints.

This cold or warm tendency that is added to the original colour is produced precisely in the same way as the modifications of aërial perspective. We have seen how the light parts of a mountain look warmer through the intervening stratum of air, whereas the darks look bluer, and that this is solely owing to the smallness of the particles floating about in the air. The white ground of our picture answers to the snowy parts of the mountain. The light that it reflects back to the eye has to run the gauntlet of the minute particles in the layer of paint above it, so that an undue proportion of the small blue waves get dispersed in the process, leaving an excess of the larger red and orange waves to reach the eye. On the contrary, when the ground is dark it absorbs nearly all the rays that reach it; but then these rays have been sifted in their progress through the layer of paint, so that an undue proportion of the larger waves get through and are absorbed, leaving an excess of the colder ones to be reflected back.

Of course it is quite possible in painting to make use of this property of pigments. There are many greys that can be obtained more readily by painting lightly over a dark ground than by mixing the required tint and painting it solidly, and there are some rich, warm tints which can hardly be obtained without a glaze of some transparent colour. Like many other things in oil-painting, what at first is a difficulty becomes, in more practised hands, an additional resource.

I must mention that the explanation I have given of the way that small particles exercise their selective influence is the one given by Helmholtz and Tyndall. Other explanations have been proposed, and I believe the subject is still a matter of controversy, but the fact that small particles do have this effect on light is undeniable, and is quite independent of any theory as to how they do it.

The space at my disposal hardly permits me to enter at greater length into the theoretical questions that underlie the art of painting, but I hope I have said enough to show not only that something is known of the theoretical side of art, but also that an acquaintance with that side of art can be of service in the practical pursuit of painting. Fortunately there are no lack of writers who have treated these questions from the scientific side, and, should any art-student wish to rest his mind from the cant and ignorance of art-critics and the meaningless eloquence of the writers on æsthetics generally, I can recommend him nothing more salutary and refreshing than a course of Helmholtz, Stokes, or Tyndall.

Who knows? some day the art of painting may become progressive; but I am convinced that that day will not come until painters learn to study their business with the same devotion and the same intelligence with which men of science study theirs.

APPENDIX.

———◦◦———

THE student should accustom himself from the very first to use none but permanent pigments, for, should he eventually be able to sell his works, he is bound in common honesty to see that they are constructed of the best and most durable materials, and are painted in a substantial and workmanlike manner.

It is true that the world would be none the worse—in fact, rather the better—if most of the pictures that are painted every year were to fade away into nothingness; yet, quite apart from the question of honesty to possible pur-chasers, it is certain that no artist will do his best unless he is firmly convinced that his works belong to the small minority which deserve immortality, and he should take every pains to make them physically capable of enduring for ever.

Fortunately, a good deal of attention has been paid of late to the question of the stability of pigments, so that it is now quite possible to draw up a very full list of colours that are known to be permanent, if only they are properly pre-pared; and also we can be tolerably certain that artists' colourmen of established reputation do prepare them pro-perly, for it is not to their interest to do otherwise. Their charges are quite sufficiently high to pay for the best skill and the best material and to yield them a large profit besides, and, as there is considerable competition in the matter, any firm whose pigments were found to deteriorate with time would very soon be crowded out by its honester or more skilful rivals.

I give below a list of all the oil-colours that are likely to be serviceable to artists, and which are sufficiently permanent to justify their use :—

Flake white.	Scarlet madder.
Zinc white.	Rose madder.
Aureolin.	Crimson madder.
Brown ochre.	Madder carmine.
Roman ochre.	Brown madder.
Yellow ochre.	Ultramarine.
Raw sienna.	Cobalt.
Cadmium (pale and deep).	French ultramarine.
Lemon yellow (pale and deep).	Ultramarine ash.
Naples yellow (pale and deep).	Oxyde of chromium.
Orange vermilion.	Emerald oxyde of chromium.
Ordinary vermilion.	Cobalt green.
Chinese vermilion.	Raw umber.
Light red.	Burnt umber.
Indian red.	Vandyke brown.
Venetian red.	Blue black.
Burnt sienna.	Ivory black.

I must mention that Professor Church (Professor of Chemistry to the Royal Academy), who has very kindly assisted me in drawing up this list, considers that the madders are not quite of the first order of permanency, changing slightly on exposure to direct sunlight. They should be used with caution, and, if possible, locked up in copal or amber varnish, which has a material effect in preserving doubtful colours. It is quite impossible to do without some kind of lake, and as all the other lakes, such as carmine or crimson lake, are quite unfit for use on account of their tendency to fade, we are obliged to have recourse to the madders. Most authorities, with the exception of Professor Church, seem to consider that the madder lakes are permanent in oil colours.

They must on no account be confounded with yellow madder, which fades very rapidly on exposure to light.

Professor Church also includes vandyke brown amongst the somewhat doubtful colours. As far as my own practice goes I have always found it permanent; but as it is not an absolutely necessary colour it may be as well to avoid it.

Considerable doubts have been cast on the stability of flake white, and zinc white has been recommended in preference; but Professor Church considers that the former is perfectly stable under all ordinary conditions, and it is particularly agreeable to use on account of its full body, whereas the latter, although quite permanent, is so thin as to be almost unfit for practical use.

It is not necessary to give a list of the unsafe colours, but there are one or two against which the student should be specially warned—for instance, lemon cadmium, or Mutrie yellow, as it is sometimes called, is very fugitive, although ordinary pale cadmium is considered quite safe. I have already mentioned that carmine, crimson lake and yellow madder are very fugitive. Bitumen, although the colour of it is permanent, is a very dangerous pigment, as it is always liable to liquefy when exposed to a moderate degree of heat, and this naturally prevents it from combining properly with other colours, and is likely eventually to produce cracks.

The medium used for painting when properly chosen tends to preserve the pigments it is used with. Copal, amber varnish, linseed-oil, nut-oil, poppy-oil, Roberson's medium, siccatif de Harlem and turpentine are all safe mediums to use. Nut-oil and poppy-oil are very slow driers, so they are not available for ordinary purposes. Turpentine should be used tolerably fresh, as it has a tendency to become yellow and resinous. The other mediums will keep indefinitely, except that they are apt to get rather thick with age.

Varnish also tends to preserve pictures, but it should

not be applied until the picture has been painted at least a year, as it is essential that all the layers of paint should be perfectly dry before the picture is varnished. Mastic is the only varnish that should be used, as it can always be rubbed off if it has got dark with age without in any way injuring the paint beneath. Before pictures are varnished it is as well to protect them with a glass, especially in London. After they are varnished the glass can be dispensed with. If there be any danger of the pictures suffering from foul air, the back of the canvas should be whitewashed with a paste made by mixing starch with flake white in powder.

It must be remembered that oil pictures, especially when freshly painted, should not be kept in the dark, as the oil in them has a tendency to grow darker when deprived of light. However, a picture that has suffered in this way can generally be restored to its proper tone by putting it for some time in sunlight to bleach. Should this not be sufficient, a solution of peroxide of hydrogen can be employed to hasten the bleaching process.

INDEX

PRINTED BY CASSELL & COMPANY, LIMITED, LA BELLE SAUVAGE, LONDON, E.C.
15.287

Illustrated, Fine-Art, and other Volumes.

Abbeys and Churches of England and Wales, The: Descriptive, Historical, Pictorial. 21s.

After London; or, Wild England. By the late RICHARD JEFFERIES. 3s. 6d.

long Alaska's Great River. By Lieut. SCHWATKA. Illustrated. 12s. 6d.

American Penman, An. By JULIAN HAWTHORNE. Boards, 2s.; cloth, 3s. 6d.

American Yachts and Yachting. Illustrated. 6s.

Arabian Nights Entertainments, The (Cassell's Pictorial Edition) With about 400 Illustrations. 10s. 6d.

Architectural Drawing. By PHENÉ SPIERS. Illustrated. 10s. 6d.

Art, The Magazine of. Yearly Vol. With 12 Photogravures, Etchings, &c , and several hundred choice Engravings. 16s.

Behind Time. By GEORGE PARSONS LATHROP. Illustrated. 2s. 6d

Bimetallism, The Theory of. By D. BARBOUR. 6s.

Bismarck, Prince. By CHARLES LOWE, M.A. Two Vols. 10s. 6d.

Black Arrow, The. A Tale of the Two Roses. By R. L. STEVENSON. 5s

British Ballads. With 275 Original Illustrations. Two Vols. 7s. 6d. each.

British Battles on Land and Sea. By the late JAMES GRANT. With about 600 Illustrations Three Vols., 4to, £1 7s.; Library Edition, £1 10s

British Battles, Recent. Illustrated. 4to, 9s.; Library Edition, 10s.

British Empire, The. By Sir GEORGE CAMPBELL, M.P. 3s.

Browning, An Introduction to the Study of. By A. SYMONS. 2s. 6d.

Butterflies and Moths, European. By W. F. KIRBY. With 61 Coloured Plates. Demy 4to, 35s.

Canaries and Cage-Birds, The Illustrated Book of. By W. A BLAKSTON, W. SWAYSLAND, and A. F. WIENER. With 56 Fac-simile Coloured Plates, 35s. Half-morocco. £2 5s.

Cannibals and Convicts. By JULIAN THOMAS ("The Vagabond"). 5s.

Captain Trafalgar. By WESTALL and LAURIE. 5s.

Cassell's Family Magazine. Yearly Vol. Illustrated. 9s.

Celebrities of the Century: being a Dictionary of Men and Women of the Nineteenth Century. 21s.; Roxburgh, 25s.

Chess Problem, The. A Text-Book, with Illustrations. 7s. 6d.

Children of the Cold, The. By Lieut. SCHWATKA. 2s. 6d.

Choice Poems by H. W. Longfellow. Illustrated. Cloth, 6s.

Choice Dishes at Small Cost. By A. G. PAYNE. 1s.

Christmas in the Olden Time. By Sir WALTER SCOTT, with Original Illustrations. 7s. 6d.

Cities of the World. Three Vols. Illustrated. 7s. 6d. each.

Civil Service, Guide to Employment in the. 3s. 6d.

Civil Service.—Guide to Female Employment in Government Offices. 1s.

Clinical Manuals for Practitioners and Students of Medicine. A List of Volumes forwarded post free on application to the Publishers.

Clothing, The Influence of, on Health. By F. TREVES, F.R C.S. 2s.

Colonies and India, Our, How we Got Them, and Why we Keep Them. By Prof. C. RANSOME. 1s.

Colour. By Prof. A. H. CHURCH. *New and Enlarged Edition*, with Coloured Plates. 3s. 6d.

Columbus, Christopher, The Life and Voyages of. By WASHINGTON IRVING. Three Vols. 7s. 6d.

Commodore Junk. By G. MANVILLE FENN. 5s.

Cookery, Cassell's Dictionary of. Containing about Nine Thousand Recipes, 7s. 6d.; Roxburgh, 10s. 6d.

Co-operators, Working Men: What they have Done, and What they are Doing. By A. H. DYKE-ACLAND, M.P., and B. JONES. 1s.

Cookery, A Year's. By PHYLLIS BROWNE. 3s. 6d.

Cookery, Cassell's Shilling. The Largest and Best Work on the Subject ever produced. 384 pages, limp cloth, 1s.

Cook Book, Catherine Owen's New. 4s.

Countries of the World, The. By ROBERT BROWN, M.A., Ph.D., &c. Complete in Six Vols., with about 750 Illustrations. 4to, 7s. 6d. each.

Culmshire Folk. By the Author of " John Orlebar," &c. 3s. 6d.

Cyclopædia, Cassell's Miniature. Containing 30,000 subjects. Cloth, 3s. 6d.

Cyclopædia, Cassell's Concise. With 12,000 subjects, brought down to the latest date. With about 600 Illustrations, 15s. ; Roxburgh, 18s.

Dairy Farming. By Prof. J. P. SHELDON. With 25 Fac-simile Coloured Plates. Cloth, 21s.

Dead Man's Rock. A Romance. By Q. 5s.

Decisive Events in History. By THOMAS ARCHER. With Sixteen Illustrations. Boards, 3s. 6d. ; cloth, 5s.

Deserted Village Series, The. Consisting of *Éditions de luxe* of the most favourite poems of Standard Authors. Illustrated. 2s. 6d. each.

SONGS FROM SHAKESPEARE.
MILTON'S L'ALLEGRO AND IL PENSEROSO.
GOLDSMITH'S DESERTED VILLAGE.
WORDSWORTH'S ODE ON IMMORTALITY, AND LINES ON TINTERN ABBEY.

Dickens, Character Sketches from. FIRST, SECOND, and THIRD SERIES. With Six Original Drawings in each by F. BARNARD. In Portfolio, 21s. each.

Diary of Two Parliaments. By W. H. LUCY. Vol. I. : The Disraeli Parliament. Vol. II. : The Gladstone Parliament. 12s. each.

Dog Stories and Dog Lore. By Col. THOS. W. KNOX. 6s.

Dog, The. By IDSTONE. Illustrated. 2s. 6d.

Dog, Illustrated Book of the. By VERO SHAW, B.A. With 28 Coloured Plates. Cloth bevelled, 35s. ; half-morocco, 45s.

Domestic Dictionary, The. Illustrated. Cloth, 7s. 6d.

Doré's Dante's Inferno. Illustrated by GUSTAVE DORÉ. 21s.

Doré's Dante's Purgatorio and Paradiso. Illustrated by GUSTAVE DORÉ. *Popular Edition.* 21s.

Doré's Fairy Tales Told Again. With Engravings by DORÉ. 5s.

Doré Gallery, The. With 250 Illustrations by DORÉ. 4to, 42s.

Doré's Milton's Paradise Lost. Illustrated by DORÉ. 4to, 21s.

Earth, Our, and its Story. By Dr. ROBERT BROWN, F.L.S. Vol. I. With Coloured Plates and numerous Wood Engravings. 9s.

Edinburgh, Old and New. Three Vols. With 600 Illustrations. 9s. each.

Egypt: Descriptive, Historical, and Picturesque. By Prof. G. EBERS Translated by CLARA BELL, with Notes by SAMUEL BIRCH, LL.D., &c. With 800 Original Engravings. *Popular Edition.* In Two Vols. 42s.

"89." A Novel. By EDGAR HENRY. Cloth, 3s. 6d.

Electricity in the Service of Man. With nearly 850 Illustrations. 21s.

Electricity, Practical. By Prof. W. E. AYRTON. 7s. 6d.

Electricity, Age of, from Amber Soul to Telephone. By PARK BENJAMIN, Ph D. 7s. 6d.

Encyclopædic Dictionary, The. A New and Original Work of Reference to all the Words in the English Language. Complete in Fourteen Divisional Vols , 10s. 6d. each ; or Seven Vols., half-morocco, 21s. each.

England, Cassell's Illustrated History of. With 2,000 Illustrations. Ten Vols., 4to, 9s. each. *New and Revised Edition.* Vols. I. and II. 9s. each.

English History, The Dictionary of. Cloth, 21s. ; Roxburgh, 25s.

English Literature, Library of. By Prof. HENRY MORLEY. Five Vols., 7s. 6d. each.

VOL. I.—SHORTER ENGLISH POEMS.
VOL. II.—ILLUSTRATIONS OF ENGLISH RELIGION.
VOL. III.—ENGLISH PLAYS.
VOL. IV.—SHORTER WORKS IN ENGLISH PROSE. [PROSE.
VOL. V.—SKETCHES OF LONGER WORKS IN ENGLISH VERSE AND

English Literature, The Story of. By ANNA BUCKLAND. 3s. 6d.

English Literature, Morley's First Sketch of. *Revised Edition,* 7s. 6d.

English Literature, Dictionary of. By W. DAVENPORT ADAMS. *Cheap Edition,* 7s. 6d.; Roxburgh, 10s. 6d.

English Writers. By Prof. HENRY MORLEY. Vols. I., II., III., and IV. Crown 8vo, 5s. each.

Æsop's Fables. Illustrated throughout by ERNEST GRISET. *Cheap Edition.* Cloth, 3s. 6d.

Etching. By S. K. KOEHLER. With 30 Full-Page Plates by Old and Modern Etchers. £4 4s.

Etiquette of Good Society. 1s.; cloth, 1s. 6d.

Europe, Pocket Guide to, Cassell's. Leather. 6s.

Eye, Ear, and Throat, The Management of the. 3s. 6d.

Fair Trade Unmasked. By GEORGE W. MEDLEY. 6d.

Family Physician, The. By Eminent PHYSICIANS and SURGEONS. *New and Revised Edition.* Cloth, 21s.; Roxburgh, 25s.

Fenn, G. Manville, Works by. Picture boards, 2s. each; or cloth, 2s. 6d. each.

MY PATIENTS. Being the Notes of a Navy Surgeon.	THE PARSON O' DUMFORD.
	THE VICAR'S PEOPLE. ⎫ In cloth
DUTCH THE DIVER.	SWEET MACE. ⎭ only.

POVERTY CORNER.

Ferns, European. By JAMES BRITTEN, F.L.S. With 30 Fac-simile Coloured Plates by D. BLAIR, F.L.S. 21s.

Field Naturalist's Handbook, The. By the Rev. J. G. WOOD and THEODORE WOOD. 5s.

Figuier's Popular Scientific Works. With Several Hundred Illustrations in each. 3s. 6d. each.

THE HUMAN RACE.	THE OCEAN WORLD.
WORLD BEFORE THE DELUGE.	THE VEGETABLE WORLD.
REPTILES AND BIRDS.	THE INSECT WORLD.

MAMMALIA.

Fine-Art Library, The. Edited by JOHN SPARKES, Principal of the South Kensington Art Schools. Each Book contains about 100 Illustrations. 5s. each.

ENGRAVING. By Le Vicomte Henri Delaborde. Translated by R. A. M. Stevenson.	THE EDUCATION OF THE ARTIST. By Ernest Chesneau. Translated by Clara Bell. (Non-illustrated.)
TAPESTRY. By Eugène Müntz. Translated by Miss L.. J. Davis.	GREEK ARCHÆOLOGY. By Maxime Collignon. Translated by Dr. J. H. Wright.
THE ENGLISH SCHOOL OF PAINTING. By E. Chesneau. Translated by L. N. Etherington. With an Introduction by Prof. Ruskin.	ARTISTIC ANATOMY. By Prof. Duval. Translated by F. E. Fenton.
THE FLEMISH SCHOOL OF PAINTING. By A. J. Wauters. Translated by Mrs. Henry Rossel.	THE DUTCH SCHOOL OF PAINTING. By Henry Havard. Translated by G. Powell.

Five Pound Note, The, and other Stories. By G. S. JEALOUS. 1s.

Flower Painting, Elementary. With Eight Coloured Plates. 3s.

Flowers, and How to Paint Them. By MAUD NAFTEL. With Coloured Plates. 5s.

Forging of the Anchor, The. A Poem. By Sir SAMUEL FERGUSON, LL.D. With 20 Original Illustrations. Gilt edges, 5s.

Fossil Reptiles, A History of British. By Sir RICHARD OWEN, K.C.B., F.R.S., &c. With 268 Plates. In Four Vols., £12 12s.

France as It Is. By ANDRÉ LEBON and PAUL PELET. With Three Maps. Crown 8vo, cloth, 7s. 6d.

Franco-German War, Cassell's History of the. Two Vols. With 500 Illustrations. 9s. each.

Fresh-water Fishes of Europe, The. By Prof. H. G. SEELEY, F.R.S. *Cheap Edition.* 7s. 6d.

From Gold to Grey. Being Poems and Pictures of Life and Nature. By MARY D. BRINE. Illustrated. 7s. 6d.

Garden Flowers, Familiar. By SHIRLEY HIBBERD. With Coloured
Plates by F. E. HULME, F.L.S. Complete in Five Series. 12s. 6d. each.
Gardening, Cassell's Popular. Illustrated. 4 vols., 5s. each.
Geometrical Drawing for Army Candidates. By H. T. LILLEY,
M.A. 2s.
Geometry, First Elements of Experimental. By PAUL BERT. 1s. 6d.
Geometry, Practical Solid. By MAJOR ROSS. 2s.
Germany, William of. A succinct Biography of William I., German
Emperor and King of Prussia. By ARCHIBALD FORBES. Crown 8vo,
cloth, 3s. 6d.
Gladstone, Life of W. E. By G. BARNETT SMITH. With Portrait. 3s. 6d.
Gleanings from Popular Authors. Two Vols. With Original Illus-
trations. 4to, 9s. each. Two Vols. in One, 15s.
Great Bank Robbery, The. A Novel. By JULIAN HAWTHORNE. Boards, 2s.
Great Industries of Great Britain. Three Vols. With about 400
Illustrations. 4to, cloth, 7s. 6d. each.
Great Painters of Christendom, The, from Cimabue to Wilkie.
By JOHN FORBES-ROBERTSON. Illustrated throughout. 12s. 6d.
Great Northern Railway, The Official Illustrated Guide to the.
1s.; or in cloth, 2s.
Great Western Railway, The Official Illustrated Guide to the.
New and Revised Edition. With Illustrations, 1s.; cloth, 2s.
Gulliver's Travels. With 88 Engravings by MORTEN. *Cheap Edition.*
Cloth, 3s. 6d.; cloth gilt, 5s.
Gum Boughs and Wattle Bloom, Gathered on Australian Hills
and Plains. By DONALD MACDONALD. 5s.
Gun and its Development, The. By W. W. GREENER. With 500
Illustrations. 10s. 6d.
Guns, Modern Shot. By W. W. GREENER. Illustrated. 5s.
Health, The Book of. By Eminent Physicians and Surgeons. Cloth,
21s.; Roxburgh, 25s.
Health, The Influence of Clothing on. By F. TREVES, F.R.G.S. 2s.
Health at School. By CLEMENT DUKES, M.D., B.S. 7s. 6d.
Heavens, The Story of the. By Sir ROBERT STAWELL BALL, F.R S.,
F.R.A.S. With Coloured Plates and Wood Engravings. 31s. 6d.
Heroes of Britain in Peace and War. In Two Vols., with 300
Original Illustrations. 5s. each; or One Vol., library binding, 10s. 6d.
Homes, Our, and How to Make them Healthy. By Eminent
Authorities. Illustrated. 15s.; Roxburgh, 18s.
Horse Keeper, The Practical. By GEORGE FLEMING, LL.D., F.R.C.V.S.
Illustrated. 7s. 6d.
Horse, The Book of the. By SAMUEL SIDNEY. With 28 *fac-simile*
Coloured Plates. *Enlarged Edition.* Demy 4to, 35s.; half-morocco, 45s.
Horses, The Simple Ailments of. By W. F. Illustrated. 5s.
Household Guide, Cassell's. Illustrated. Four Vols., 20s.
How Dante Climbed the Mountain. By ROSE EMILY SELFE. With
Eight Full-page Engravings by GUSTAVE DORÉ. 2s.
How Women may Earn a Living. By MERCY GROGAN. 1s.
India, Cassell's History of. By JAMES GRANT. With about 400
Illustrations. Library binding. One Vol. 15s.
India: the Land and the People. By Sir J. CAIRD, K.C.B. 10s. 6d.
Indoor Amusements, Card Games, and Fireside Fun, Cassell's
Book of. Illustrated. 3s. 6d.
Irish Parliament, The; What it Was and What it Did. By J. G.
SWIFT MACNEILL, M.A., M.P. 1s.
Irish Parliament, A Miniature History of the. By J. C. HASLAM. 3d.
Irish Union, The; Before and After. By A. K. CONNELL, M.A. 2s. 6d.
John Parmelee's Curse. By JULIAN HAWTHORNE. 2s. 6d.
Kennel Guide, The Practical. By Dr. GORDON STABLES. 1s.
Khiva, A Ride to. By Col. FRED. BURNABY. 1s. 6d.
Kidnapped. By R. L. STEVENSON. *Illustrated Edition.* 5s.
King Solomon's Mines. By H. RIDER HAGGARD. *Illustrated Edition* 5s.

Ladies' Physician, The. A Guide for Women in the Treatment of their Ailments. By a Physician. 6s.

Lady Biddy Fane. By FRANK BARRETT. Three Vols. Cloth, 31s. 6d.

Lady's World, The. An Illustrated Magazine of Fashion and Society. Yearly Vol. 18s.

Land Question, The. By Prof. J. ELLIOT, M.R.A.C. Including the Land Scare and Production of Cereals. 3s. 6d.

Landscape Painting in Oils, A Course of Lessons in. By A. F. GRACE. With Nine Reproductions in Colour. *Cheap Edition,* 25s

Law, About Going to. By A. J. WILLIAMS, M.P. 2s. 6d.

Legends for Lionel. By WALTER CRANE. Coloured Illustrations. 5s.

Letts's Diaries and other Time-saving Publications are now published exclusively by CASSELL & COMPANY. (*A list free on application.*)

Local Dual Standards. Gold and Silver Currencies. By J. H. NORMAN. 1s.

Local Government in England and Germany. By the Right Hon. Sir ROBERT MORIER, G.C.B., &c. 1s.

London, Brighton, and South Coast Railway, The Official Illustrated Guide to the. 1s. ; cloth, 2s.

London and North Western Railway, The Official Illustrated Guide to the. 1s. , cloth, 2s.

London and South Western Railway, The Official Illustrated Guide to the. 1s. ; cloth, 2s.

London, Greater. By EDWARD WALFORD. Two Vols. With about 400 Illustrations. 9s. each.

London, Old and New. Six Vols., each containing about 200 Illustrations and Maps. Cloth, 9s. each. [*Edition,* 16s.

Longfellow's Poetical Works. Illustrated throughout, £3 3s.; *Popular*

Luther, Martin: His Life and Times. By PETER BAYNE, LL.D. Two Vols., demy 8vo, 1,040 pages. Cloth, 24s.

Mechanics, The Practical Dictionary of. Containing 15,000 Drawings. Four Vols. 21s. each.

Medicine, Manuals for Students of. (*A List forwarded post free.*)

Midland Railway, Official Illustrated Guide to the. *New and Revised Edition.* 1s. ; cloth, 2s.

Modern Europe, A History of. By C. A. FYFFE, M.A. Vol. I., from 1792 to 1814. 12s. Vol. II., from 1814 to 1848. 12s.

Music, Illustrated History of. By EMIL NAUMANN. Edited by the Rev. Sir F. A. GORE OUSELEY, Bart. Illustrated. Two Vols. 31s. 6d.

National Library, Cassell's. In Weekly Volumes, each containing about 192 pages. Paper covers, 3d. ; cloth, 6d. (*A List of the Volumes already issued sent post free on application.*)

Natural History, Cassell's Concise. By E. PERCEVAL WRIGHT, M.A., M.D., F.L.S. With several Hundred Illustrations. 7s. 6d.

Natural History, Cassell's New. Edited by Prof. P. MARTIN DUNCAN, M.B., F.R.S., F.G.S. Complete in Six Vols. With about 2,000 Illustrations. Cloth, 9s. each.

Nimrod in the North; or, Hunting and Fishing Adventures in the Arctic Regions. By Lieut. SCHWATKA. Illustrated. 7s. 6d.

Nursing for the Home and for the Hospital, A Handbook of. By CATHERINE J. WOOD. *Cheap Edition.* 1s. 6d. ; cloth, 2s.

Oil Painting, A Manual of. By the Hon. JOHN COLLIER. 2s. 6d.

Orion the Gold Beater. A Novel. By SYLVANUS COBB, Junr. Cloth, 3s. 6d.

Our Own Country. Six Vols. With 1,200 Illustrations. 7s. 6d. each.

Out-door Sports and In-door Amusements, Cassell's Book of. With more than 900 Illustrations. *Cheap Edition.* 992 pages. Medium 8vo, cloth, 3s. 6d.

Painting, Practical Guides to. With Coloured Plates and full instructions:—Marine Painting, 5s.—Animal Painting, 5s.—China Painting, 5s.—Figure Painting, 7s. 6d.—Elementary Flower Painting, 3s.—Flower Painting, 2 Books, 5s. each.—Tree Painting, 5s.—Water-Colour Painting, 5s.—Neutral Tint, 5s.—Sepia, in 2 Vols., 3s. each; or in One Vol., 5s.—Flowers, and How to Paint Them, 5s.

Paris, Cassell's Illustrated Guide to. Cloth, 2s.

Parliaments, A Diary of Two. By H. W. LUCY. The Disraeli Parliament, 1874—1880. 12s. The Gladstone Parliament, 1881—1886. 12s.

Paxton's Flower Garden. By Sir JOSEPH PAXTON and Prof. LINDLEY Three Vols. With 100 Coloured Plates. £1 1s. each.

Peoples of the World, The. In Six Vols. By Dr. ROBERT BROWN. Illustrated. 7s. 6d. each.

Phantom City, The. By W. WESTALL. *Second Edition.* 5s.

Photography for Amateurs. By T. C. HEPWORTH. Illustrated. 1s.; or cloth, 1s. 6d.

Phrase and Fable, Dictionary of. By the Rev. Dr. BREWER. *Cheap Edition, Enlarged*, cloth, 3s. 6d. ; or with leather back, 4s. 6d.

Picturesque America. Complete in Four Vols., with 48 Exquisite Steel Plates and about 800 Original Wood Engravings. £2 2s. each.

Picturesque Canada. With 600 Original Illustrations. 2 Vols. £3 3s. each.

Picturesque Europe. Complete in Five Vols. Each containing 13 Exquisite Steel Plates, from Original Drawings, and nearly 200 Original Illustrations. £10 10s. The POPULAR EDITION is published in Five Vols., 18s. each.

Pigeon Keeper, The Practical. By LEWIS WRIGHT. Illustrated. 3s. 6d.

Pigeons, The Book of. By ROBERT FULTON. Edited and Arranged by L. WRIGHT. With 50 Coloured Plates, 31s. 6d. ; half-morocco, £2 2s.

Poets, Cassell's Miniature Library of the :—

BURNS. Two Vols. 2s. 6d.	MILTON. Two Vols. 2s. 6d.
BYRON. Two Vols. 2s. 6d.	SCOTT. Two Vols. 2s. 6d. [2s. 6d.
HOOD. Two Vols. 2s. 6d.	SHERIDAN and GOLDSMITH. 2 Vols.
LONGFELLOW. Two Vols. 2s. 6d.	WORDSWORTH. Two Vols. 2s. 6d.

SHAKESPEARE. Illustrated. In 12 Vols., in Case, 12s.

Police Code, and Manual of the Criminal Law. By C. E. HOWARD VINCENT, M.P. 2s.

Popular Library, Cassell's. Cloth, 1s. each.

The Russian Empire.	The Story of the English Jacobins.
The Religious Revolution in the 16th Century.	Domestic Folk Lore.
English Journalism.	The Rev. Rowland Hill: Preacher and Wit.
Our Colonial Empire.	Boswell and Johnson : their Companions and Contemporaries.
John Wesley.	History of the Free-Trade Movement in England.
The Young Man in the Battle of Life.	

Post Office of Fifty Years Ago, The. Containing Reprint of Sir ROWLAND HILL's famous Pamphlet proposing Penny Postage. 1s.

Poultry Keeper, The Practical. By LEWIS WRIGHT. With Coloured Plates and Illustrations. 3s. 6d.

Poultry, The Illustrated Book of. By LEWIS WRIGHT. With Fifty Coloured Plates. Cloth, 31s. 6d. ; half-morocco, £2 2s.

Poultry, The Book of. By LEWIS WRIGHT. *Popular Edition.* 10s. 6d.

Pre-Raphaelites, The Italian, in the National Gallery. By COSMO MONKHOUSE. Illustrated. 1s.

Printing Machinery and Letterpress Printing, Modern. By J. F. WILSON and DOUGLAS GREY. Illustrated. 21s.

Queen Victoria, The Life and Times of. By ROBERT WILSON. Complete in Two Vols. With numerous Illustrations. 9s. each.

Queer Race, A. By W. WESTALL. 5s.

Quiver, The. Yearly Volume. Containing Several Hundred Illustrations. 7s. 6d.

Rabbit-Keeper, The Practical. By CUNICULUS. Illustrated. 3s. 6d.

Representative Poems of Living Poets American and English. Selected by the Poets themselves. 15s.

Republic of the Future, The. By ANNA BOWMAN DODD. 2s.

Royal River, The : The Thames from Source to Sea. With Descriptive Text and a Series of beautiful Engravings. £2 2s.

Red Library, Cassell's. Stiff covers, 1s. each; cloth, 2s. each.

People I have Met.
The Pathfinder.
Evelina.
Scott's Poems.
Last of the Barons.
Adventures of Mr. Ledbury.
Ivanhoe.
Oliver Twist.
Selections from Hood's Works.
Longfellow's Prose Works.
Sense and Sensibility.
Lytton's Plays. [Harte.
Tales, Poems, and Sketches. Bret
Martin Chuzzlewit (2 Vols.).
The Prince of the House of
Sheridan's Plays. [David.
Uncle Tom's Cabin.
Deerslayer.
Eugene Aram.
Jack Hinton, the Guardsman.
Rome and the Early Christians.
The Trials of Margaret Lyndsay.

Poe's Works.
Old Mortality.
The Hour and the Man.
Handy Andy.
Scarlet Letter.
Pickwick (2 Vols.)
Last of the Mohicans.
Pride and Prejudice.
Yellowplush Papers.
Tales of the Borders.
Last Days of Palmyra.
Washington Irving's Sketch-
Book.
The Talisman.
Rienzi.
Old Curiosity Shop.
Heart of Midlothian.
Last Days of Pompeii.
American Humour.
Sketches by Boz.
Macaulay's Lays and Essays.
Harry Lorrequer.

Russia. By Sir DONALD MACKENZIE WALLACE, M.A. With a new Autobiographical Chapter. 5s.

Russo-Turkish War, Cassell's History of. With about 500 Illustrations. Two Vols., 9s. each.

Saturday Journal, Cassell's. Yearly Volume, cloth, 7s. 6d.

Science for All. Edited by Dr. ROBERT BROWN. Illustrated. Five Vols. 9s. each.

Sea, The: Its Stirring Story of Adventure, Peril, and Heroism. By F. WHYMPER. With 400 Illustrations. Four Vols., 7s. 6d. each.

Section 558, or The Fatal Letter. A Novel. By JULIAN HAWTHORNE. Boards, 2s.; cloth, 3s. 6d.

Sent Back by the Angels. And other Ballads. By FREDERICK LANGBRIDGE, M.A. Cloth, 4s. 6d. *Popular Edition*, 1s.

Shaftesbury, The Seventh Earl of, K.G., The Life and Work of. By EDWIN HODDER. With Portraits. Three Vols., 36s. *Popular Edition*, in One Vol., 7s. 6d.

Shakspere, The International. *Édition de Luxe.* "King Henry IV.," Illustrated by Herr EDUARD GRUTZNER, £3 10s.; "As You Like It," Illustrated by Mons. EMILE BAYARD, £3 10s.; "Romeo and Juliet," Illustrated by FRANK DICKSEE, A.R.A., £5 5s.

Shakspere, The Leopold. With 400 Illustrations. Cloth, 6s.; cloth gilt, 7s. 6d.; half-morocco, 10s. 6d. *Cheap Edition.* 3s. 6d.

Shakspere, The Royal. With Steel Plates and Wood Engravings. Three Vols. 15s. each.

Shakespeare, Cassell's Quarto Edition. Edited by CHARLES and MARY COWDEN CLARKE, and containing about 600 Illustrations by H. C. SELOUS. Complete in Three Vols., cloth gilt, £3 3s.

Shakespeare, Miniature. Illustrated. In Twelve Vols., in box, 12s.; or in Red Paste Grain (box to match), with lock and key, 21s.

Shakespearean Scenes and Characters. With 30 Steel Plates and 10 Wood Engravings. The Text written by AUSTIN BRERETON. 21s.

Ships, Sailors, and the Sea. By R. J. CORNEWALL-JONES. Illustrated. 5s.

Short Studies from Nature. Illustrated. *Cheap Edition.* 2s. 6d.

Sketching from Nature in Water Colours. By AARON PENLEY. With Illustrations in Chromo-Lithography. 15s.

Skin and Hair, The Management of the. By M. MORRIS, F.R.C.S. 2s.

Sonnets and Quatorzains. By CHRYS, M.A. Oxon. 5s.

Steam Engine, The Theory and Action of the: for Practical Men. By W. H. NORTHCOTT, C.E. 3s. 6d.

Stock Exchange Year-Book, The. By THOMAS SKINNER. 12s. 6d.

Summer Tide. "Little Folks" Holiday Number. 1s.

Sunlight and Shade. With numerous Exquisite Engravings. 7s. 6d.
Surgery, Memorials of the Craft of, in England. With an Intro-
 duction by Sir JAMES PAGET. 21s.
Technical Education. By F. C. MONTAGUE. 6d.
Thackeray, Character Sketches from. Six New and Original Draw-
 ings by FREDERICK BARNARD, reproduced in Photogravure. 21s.
Town Holdings. 1s.
Tragedy of Brinkwater, The. A Novel. By MARTHA L. MOODEY.
 Boards, 2s. ; cloth, 3s. 6d.
Tragic Mystery, A. A Novel. By JULIAN HAWTHORNE. Boards, 2s.
Treasure Island. By R. L. STEVENSON. Illustrated. 5s.
Treatment, The Year-Book of. 5s.
Trees, Familiar. By G. S. BOULGER, F.L.S. Two Series. With 40
 full-page Coloured Plates, from Original Paintings by W. H. J. BOOT.
 12s. 6d. each.
Twenty Photogravures of Pictures in the Salon of 1885, by the
 leading French Artists.
"Unicode": the Universal Telegraphic Phrase Book. *Desk and
 Pocket Editions.* 2s. 6d. each.
United States, Cassell's History of the. By the late EDMUND
 OLLIER. With 600 Illustrations. Three Vols. 9s. each.
United States, The Youth's History of the. By EDWARD S. ELLIS.
 Illustrated. Four Volumes. 36s.
Universal History, Cassell's Illustrated. Four Vols. 9s. each.
Vaccination Vindicated. By JOHN McVAIL, M.D., D.P.H. Camb. 5s.
Veiled Beyond, The. A Novel. By S. B. ALEXANDER. Cloth, 3s. 6d.
Vicar of Wakefield and other Works by OLIVER GOLDSMITH.
 Illustrated. 3s. 6d. ; cloth, gilt edges, 5s.
What Girls Can Do. By PHYLLIS BROWNE. 2s. 6d.
Who is John Noman? A Novel. By CHARLES HENRY BECKETT.
 Boards, 2s. ; cloth, 3s. 6d.
Wild Birds, Familiar. By W. SWAYSLAND. Four Series. With 40
 Coloured Plates in each. 12s. 6d. each.
Wild Flowers, Familiar. By F. E. HULME, F.L.S., F.S.A. Five
 Series. With 40 Coloured Plates in each. 12s. 6d. each.
Wise Woman, The. By GEORGE MACDONALD. 2s. 6d.
Woman's World, The. Yearly Volume. 18s.
World of Wit and Humour, The. With 400 Illustrations. Cloth,
 7s. 6d. ; cloth gilt, gilt edges, 10s. 6d.
World of Wonders. Two Vols. With 400 Illustrations. 7s. 6d. each.
Yoke of the Thorah, The. A Novel. By SIDNEY LUSKA. Boards,
 2s. ; cloth, 3s. 6d.
Yule Tide. Cassell's Christmas Annual, 1s.

ILLUSTRATED MAGAZINES.

The Quiver. ENLARGED SERIES. Monthly, 6d.
Cassell's Family Magazine. Monthly, 7d.
"Little Folks" Magazine. Monthly, 6d.
The Magazine of Art. Monthly, 1s.
The Woman's World. Monthly, 1s.
Cassell's Saturday Journal. Weekly, 1d. ; Monthly, 6d.

Catalogues of CASSELL & COMPANY'S PUBLICATIONS, which may be had at all
 Booksellers', or will be sent post free on application to the Publishers :—
 CASSELL'S COMPLETE CATALOGUE, containing particulars of upwards of
 One Thousand Volumes.
 CASSELL'S CLASSIFIED CATALOGUE, in which their Works are arranged
 according to price, from *Threepence to Twenty-five Guineas.*
 CASSELL'S EDUCATIONAL CATALOGUE, containing particulars of CASSELL
 & COMPANY'S Educational Works and Students' Manuals.

CASSELL & COMPANY, LIMITED, *Ludgate Hill, London.*

𝔅ibles and 𝔕eligious 𝔚orks.

Bible, The Crown Illustrated. With about 1,000 Original Illustrations. With References, &c. 1,248 pages, crown 4to, cloth, 7s. 6d.

Bible, Cassell's Illustrated Family. With 900 Illustrations. Leather, gilt edges, £2 10s.

Bible Dictionary, Cassell's. With nearly 600 Illustrations. 7s. 6d.

Bible Educator, The. Edited by the Very Rev. Dean PLUMPTRE, D.D., Wells. With Illustrations, Maps, &c. Four Vols., cloth, 6s. each.

Bible Work at Home and Abroad. Volume. Illustrated. 3s.

Bunyan's Pilgrim's Progress (Cassell's Illustrated). 4to. 7s. 6d.

Bunyan's Pilgrim's Progress. With Illustrations. Cloth, 3s. 6d.

Child's Life of Christ, The. With 200 Illustrations. 21s.

Child's Bible, The. With 200 Illustrations. 143*rd Thousand.* 7s. 6d.

Doré Bible. With 238 Illustrations by GUSTAVE DORÉ. Small folio, cloth, £8.

Early Days of Christianity, The. By the Ven. Archdeacon FARRAR D.D., F.R.S.
LIBRARY EDITION. Two Vols., 24s. ; morocco, £2 2s.
POPULAR EDITION. Complete in One Volume, cloth, 6s. ; cloth, gilt edges, 7s. 6d. ; Persian morocco, 10s. 6d. ; tree-calf, 15s.

Family Prayer-Book, The. Edited by Rev. Canon GARBETT, M.A., and Rev. S. MARTIN. Extra crown 4to, cloth, 5s. ; morocco, 18s.

Geikie, Cunningham, D.D., Works by :—
THE HOLY LAND AND THE BIBLE. A Book of Scripture Illustrations gathered in Palestine. Two Vols., demy 8vo, with Map. 24s.
HOURS WITH THE BIBLE. Six Vols., 6s. each.
ENTERING ON LIFE. 3s. 6d.
THE PRECIOUS PROMISES. 2s. 6d.
THE ENGLISH REFORMATION. 5s.
OLD TESTAMENT CHARACTERS. 6s.
THE LIFE AND WORDS OR CHRIST. *Illustrated Edition*—Two Vols., 30s. ; *Library Edition*—Two Vols., 30s. ; *Students' Edition*—Two Vols., 16s. ; *Cheap Edition*—One Vol., 7s. 6d.

Glories of the Man of Sorrows, The. Sermons preached at St. James's, Piccadilly. By Rev. H. G. BONAVIA HUNT, Mus.D., F.R.S., Ed. 2s. 6d.

Gospel of Grace, The. By a LINDESIE. Cloth, 3s. 6d.

"Heart Chords." A Series of Works by Eminent Divines. Bound in cloth, red edges, One Shilling each.

My Father.	My Aspirations.	My Hereafter.
My Bible.	My Emotional Life.	My Walk with God.
My Work for God.	My Body.	My Aids to the Divine Life.
My Object in Life.	My Soul.	My Sources of Strength.
	My Growth in Divine Life.	

Helps to Belief. A Series of Helpful Manuals on the Religious Difficulties of the Day Edited by the Rev. TEIGNMOUTH SHORE, M.A., Chaplain-in-Ordinary to the Queen. Cloth, 1s. each.

CREATION. By the Lord Bishop of Carlisle.
THE DIVINITY OF OUR LORD. By the Lord Bishop of Derry.
THE MORALITY OF THE OLD TESTAMENT By the Rev Newman Smyth, D.D.

MIRACLES By the Rev. Brownlow Maitland, M A.
PRAYER. By the Rev. T. Teignmouth Shore, M.A.
THE ATONEMENT. By he Lord Bishop of Peterborough

5 B. 7.88

I Must. Short Missionary Bible Readings. By Sophia M. Nugent. Enamelled covers, 6d. ; cloth, gilt edges, 1s.

Life of Christ, The. By the Ven. Archdeacon Farrar, D.D., F.R.S.
ILLUSTRATED EDITION, with about 300 Original Illustrations. Extra crown 4to, cloth, gilt edges, 21s. ; morocco antique, 42s.
LIBRARY EDITION. Two Vols. Cloth, 24s. ; morocco, 42s.
POPULAR EDITION, in One Vol. 8vo, cloth, 6s. ; cloth, gilt edges, 7s. 6d. ; Persian morocco, gilt edges, 10s. 6d. ; tree-calf, 15s.

Luther, Martin: His Life and Times. By Peter Bayne, LL.D. Two Vols., demy 8vo, 1,040 pages. Cloth, 24s.

Marriage Ring, The. By William Landels, D.D. Bound in white leatherette, gilt edges, in box, 6s. ; French morocco, 8s. 6d.

Moses and Geology ; or, The Harmony of the Bible with Science. By the Rev. Samuel Kinns, Ph.D., F.R.A.S. Illustrated. *Cheap Edition*, 6s.

New Testament Commentary for English Readers, The. Edited by the Rt. Rev. C. J. Ellicott, D.D., Lord Bishop of Gloucester and Bristol. In Three Volumes, 21s. each.

Vol. I.—The Four Gospels.
Vol. II.—The Acts, Romans, Corinthians, Galatians.
Vol. III.—The remaining Books of the New Testament.

Old Testament Commentary for English Readers, The. Edited by the Right Rev. C. J. Ellicott, D.D., Lord Bishop of Gloucester and Bristol. Complete in 5 Vols., 21s. each.

Vol. I.—Genesis to Numbers.
Vol. II.—Deuteronomy to Samuel II.
Vol. III.—Kings I. to Esther.
Vol. IV.—Job to Isaiah.
Vol. V.—Jeremiah to Malachi.

Protestantism, The History of. By the Rev. J. A. Wylie, LL.D. Containing upwards of 600 Original Illustrations Three Vols., 9s. each.

Quiver Yearly Volume, The. 250 high-class Illustrations. 7s. 6d.

Religion, The Dictionary of. By the Rev. W. Benham, B.D. 21s.; Roxburgh, 25s.

St. George for England ; and other Sermons preached to Children. By the Rev. T. Teignmouth Shore, M.A. 5s.

St. Paul, The Life and Work of. By the Ven. Archdeacon Farrar, D.D., F.R.S., Chaplain-in-Ordinary to the Queen.
LIBRARY EDITION. Two Vols., cloth, 24s. ; calf, 42s.
ILLUSTRATED EDITION, complete in One Volume, with about 300 Illustrations, £1 1s. ; morocco, £2 2s.
POPULAR EDITION. One Volume, 8vo, cloth, 6s.; cloth, gilt edges, 7s. 6d. ; Persian morocco, 10s. 6d. ; tree-calf, 15s.

Secular Life, The Gospel of the. Sermons preached at Oxford. By the Hon. W. H. Fremantle, Canon of Canterbury. 5s.

Shall We Know One Another ? By the Rt. Rev. J. C Ryle, D.D., Bishop of Liverpool. *New and Enlarged Edition.* Cloth limp, 1s.

Twilight of Life, The. Words of Counsel and Comfort for the Aged. By the Rev. John Ellerton, M.A. 1s. 6d.

Voice of Time, The. By John Stroud. Cloth gilt, 1s.

Educational Works and Students' Manuals.

Alphabet, Cassell's Pictorial. 3s. 6d.

Arithmetics, The Modern School. By GEORGE RICKS, B.Sc. Lond. With Test Cards. (*List on application.*)

Book-Keeping. By THEODORE JONES. For Schools, 2s.; cloth, 3s. For the Million, 2s.; cloth, 3s. Books for Jones's System. 2s.

Chemistry, The Public School. By J. H. ANDERSON, M.A. 2s. 6d.

Commentary, The New Testament. Edited by the Lord Bishop of GLOUCESTER and BRISTOL. Handy Volume Edition. St. Matthew, 3s. 6d. St. Mark, 3s. St. Luke, 3s. 6d. St. John, 3s. 6d. The Acts of the Apostles, 3s. 6d. Romans, 2s. 6d. Corinthians I. and II., 3s. Galatians, Ephesians, and Philippians, 3s. Colossians, Thessalonians, and Timothy, 3s. Titus, Philemon, Hebrews, and James, 3s. Peter, Jude, and John, 3s. The Revelation, 3s. An Introduction to the New Testament, 3s. 6d.

Commentary, Old Testament. Edited by Bishop ELLICOTT. Handy Volume Edition. Genesis, 3s. 6d. Exodus, 3s. Leviticus, 3s. Numbers, 2s. 6d. Deuteronomy, 2s. 6d.

Copy-Books, Cassell's Graduated. *Eighteen Books.* 2d. each.

Copy-Books, The Modern School. *Twelve Books.* 2d. each.

Drawing Copies, Cassell's "New Standard." *Fourteen Books.* Books A to F for Standards I. to IV., 2d. each. Books G, H, K, L, M, O, for Standards V. to VII., 3d. each. Books N and P, 4d. each.

Drawing Copies, Cassell's Modern School Freehand. First Grade 1s.; Second Grade, 2s.

Electricity, Practical. By Prof. W. E. AYRTON. 7s. 6d.

Energy and Motion: A Text-Book of Elementary Mechanics. By WILLIAM PAICE, M.A. Illustrated. 1s. 6d.

English Literature, First Sketch of. *New and Enlarged Edition.* By Prof. MORLEY. 7s. 6d.

English Literature, The Story of. By ANNA BUCKLAND. Cloth boards, 3s. 6d.

Euclid, Cassell's. Edited by Prof. WALLACE, M.A. 1s.

Euclid, The First Four Books of. In paper, 6d.; cloth, 9d.

Experimental Geometry, Elements of. By PAUL BERT. Fully Illustrated. 1s. 6d.

French Reader, Cassell's Public School. By GUILLAUME S. CONRAD. 2s. 6d.

French, Cassell's Lessons in. *New and Revised Edition.* Parts I. and II., each 2s. 6d.; complete, 4s. 6d. Key, 1s. 6d.

French-English and English-French Dictionary. *Entirely New and Enlarged Edition.* 1,150 pages, 8vo, cloth, 3s. 6d.

Galbraith and Haughton's Scientific Manuals. By the Rev. Prof. GALBRAITH, M.A., and the Rev. Prof. HAUGHTON, M.D., D.C.L. Arithmetic, 3s. 6d.—Plane Trigonometry, 2s. 6d.—Euclid, Books I., II., III., 2s. 6d.—Books IV., V., VI., 2s. 6d.—Mathematical Tables, 3s. 6d.—Mechanics, 3s. 6d.—Natural Philosophy, 3s. 6d.—Optics, 2s. 6d.—Hydrostatics, 3s. 6d.—Astronomy, 5s.—Steam Engine, 3s. 6d.—Algebra, Part I., cloth, 2s. 6d.; Complete, 7s. 6d.—Tides and Tidal Currents, with Tidal Cards, 3s.

German-English and English-German Dictionary. 3s. 6d.

German Reading, First Lessons in. By A. JAGST. Illustrated. 1s.

German of To-Day. By Dr. HEINEMANN. 1s. 6d.

Handbook of New Code of Regulations. By JOHN F. MOSS. 1s.

Historical Cartoons, Cassell's Coloured. Size 45 in. x 35 in., 2s. each. Mounted on canvas and varnished, with rollers, 5s. each.

Historical Course for Schools, Cassell's. Illustrated throughout. I.—Stories from English History, 1s. II.—The Simple Outline of English History, 1s. 3d. III.—The Class History of England, 2s. 6d.

Latin-English Dictionary, Cassell's. By J. R. V. MARCHANT, M.A. 3s. 6d.

Latin-English and English-Latin Dictionary. By J. R. BEARD, D.D., and C. BEARD, B.A. Crown 8vo, 914 pp., 3s. 6d.

Latin Primer, The New. By Prof. J. P. POSTGATE. Crown 8vo, 2s. 6d.

Laws of Every-Day Life. By H. O. ARNOLD-FORSTER. 1s. 6d.

Little Folks' History of England. By ISA CRAIG-KNOX. Illustrated. 1s. 6d.

Making of the Home, The: A Book of Domestic Economy for School and Home Use. By Mrs. SAMUEL A. BARNETT. 1s. 6d.

Marlborough Books:—Arithmetic Examples, 3s. Arithmetic Rules, 1s. 6d. French Exercises, 3s. 6d. French Grammar, 2s. 6d. German Grammar, 3s. 6d.

Mechanics and Machine Design, Numerical Examples in Practical. By R. G. BLAINE, M.E. With Diagrams. Cloth, 2s. 6d.

Music, An Elementary Manual of. By HENRY LESLIE. 1s.

Popular Educator, Cassell's. Complete in Six Vols., 5s. each.

Readers, Cassell's "Higher Class." "The World's Lumber-room." Illustrated. 2s. 6d.—"Short Studies from Nature." Illustrated. 2s. 6d. —"The World in Pictures." Ten in Series. Cloth, 2s. each.

Readers, Cassell's Readable. Carefully graduated, extremely interesting, and illustrated throughout. (*List on application.*)

Readers, Cassell's Historical. Illustrated throughout, printed on superior paper, and strongly bound in cloth. (*List on application.*)

Readers for Infant Schools, Coloured. Three Books. Each containing 48 pages, including 8 pages in colours. 4d. each.

Reader, The Citizen. By H. O. ARNOLD-FORSTER. Illustrated. 1s. 6d.

Readers, The "Modern School" Geographical. (*List on application.*)

Readers, The "Modern School." Illustrated. (*List on application.*)

Reading and Spelling Book, Cassell's Illustrated. 1s.

School Bank Manual. By AGNES LAMBERT. Price 6d.

Shakspere's Plays for School Use. 5 Books. Illustrated, 6d. each.

Shakspere Reading Book, The. By H. COURTHOPE BOWEN, M.A. Illustrated. 3s. 6d. Also issued in Three Books, 1s. each.

Slöjd: as a Means of Teaching the Essential Elements of Education. By EMILY LORD. 6d.

Spelling, A Complete Manual of. By J. D. MORELL, LL.D. 1s.

Technical Manuals, Cassell's. Illustrated throughout :— Handrailing and Staircasing, 3s. 6d.—Bricklayers, Drawing for, 3s.— Building Construction, 2s.—Cabinet-Makers, Drawing for, 3s.—Carpenters and Joiners, Drawing for, 3s. 6d.—Gothic Stonework, 3s. —Linear Drawing and Practical Geometry, 2s.—Linear Drawing and Projection. The Two Vols. in One, 3s. 6d.—Machinists and Engineers, Drawing for, 4s. 6d.—Metal-Plate Workers, Drawing for, 3s.—Model Drawing, 3s.—Orthographical and Isometrical Projection, 2s.—Practical Perspective, 3s.—Stonemasons, Drawing for, 3s.—Applied Mechanics, by Sir R. S. Ball, LL.D., 2s.—Systematic Drawing and Shading, 2s.

Technical Educator, Cassell's. *New Edition*, in Four Vols., 5s. each.

Technology, Manuals of. Edited by Prof. AVETON, F.R.S., and RICHARD WORMELL, D.Sc., M.A. Illustrated throughout :— The Dyeing of Textile Fabrics, by Prof. Hummel, 5s.—Watch and Clock Making, by D. Glasgow, 4s. 6d.—Steel and Iron, by Prof. W. H. Greenwood, F.C.S., M.I.C.E., &c., 5s.—Spinning Woollen and Worsted, by W. S. B. McLaren, M.P., 4s. 6d.—Design in Textile Fabrics, by T. R. Ashenhurst, 4s. 6d.—Practical Mechanics, by Prof. Perry, M.E., 3s. 6d.—Cutting Tools Worked by Hand and Machine, by Prof. Smith, 3s. 6d. *A Prospectus on application.*

Test Cards, "Modern School," Cassell's. In Sets, for each Standard. 1s. each. With Mental Arithmetic on reverse side.

Test Cards, Cassell's Combination. In sets, 1s. each.

CASSELL & COMPANY, LIMITED, *Ludgate Hill, London.*

Books for Young People.

"**Little Folks**" Half-Yearly Volume. Containing 432 4to pages with about 200 Illustrations, and Pictures in Colour. Boards, 3s. 6d.; or cloth gilt, 5s.

Bo-Peep. A Book for the Little Ones. With Original Stories and Verses. Illustrated throughout. Yearly Volume. Boards, 2s. 6d.; cloth gilt, 3s. 6d.

Legends for Lionel. New Picture Book by WALTER CRANE. 5s.

Flora's Feast. A Masque of Flowers. Penned and Pictured by WALTER CRANE. With 40 Pages in Colours. 5s.

Every-day Heroes. By LAURA LANE. Illustrated. Cloth, 2s. 6d.

The New Children's Album. Fcap. 4to, 320 pages. Illustrated throughout. 3s. 6d.

The Tales of the Sixty Mandarins. By P. V. RAMASWAMI RAJU. With an Introduction by Prof. HENRY MORLEY. Illustrated. 5s.

The World's Lumber Room. By SELINA GAYE. 2s. 6d.

Books for Young People. Illustrated. Cloth gilt, 5s. each.

The Palace Beautiful. By L. T. Meade.
The King's Command: A Story for Girls. By Maggie Symington.
For Fortune and Glory: A Story of the Soudan War. By Lewis Hough.
"Follow My Leader;" or, The Boys of Templeton. By Talbot Baines Reed.

Under Bayard's Banner. By Henry Frith.
The Romance of Invention. By James Burnley.
The Champion of Odin; or, Viking Life in the Days of Old. By J. Fred. Hodgetts.
Bound by a Spell; or, The Hunted Witch of the Forest. By the Hon. Mrs. Greene.

Books for Young People. Illustrated. Price 3s. 6d. each.

The Cost of a Mistake. By Sarah Pitt.
A World of Girls: The Story of a School. By L. T. Meade.
Lost among White Africans: A Boy's Adventures on the Upper Congo. By David Ker.
Freedom's Sword: A Story of the Days of Wallace and Bruce. By Annie S. Swan.

On Board the "Esmeralda;" or, Martin Leigh's Log. By John C. Hutcheson.
In Quest of Gold; or, Under the Whanga Falls. By Alfred St. Johnston.
For Queen and King; or, The Loyal 'Prentice. By Henry Frith.
Perils Afloat and Brigands Ashore. By Alfred Elwes.

The "Cross and Crown" Series. Consisting of Stories founded on incidents which occurred during Religious Persecutions of Past Days. With Illustrations in each Book. 2s. 6d. each.

Strong to Suffer: A Story of the Jews. By E. Wynne.
Heroes of the Indian Empire; or, Stories of Valour and Victory. By Ernest Foster.
In Letters of Flame: A Story of the Waldenses. By C. L. Matéaux.
Through Trial to Triumph. By Madeline B. Hunt.

By Fire and Sword: A Story of the Huguenots. By Thomas Archer.
Adam Hepburn's Vow: A Tale of Kirk and Covenant. By Annie S. Swan.
No. XIII.; or, The Story of the Lost Vestal. A Tale of Early Christian Days. By Emma Marshall.

"**Golden Mottoes**" Series, The. Each Book containing 208 pages, with Four full-page Original Illustrations. Crown 8vo, cloth gilt, 2s. each.

"Nil Desperandum." By the Rev. F. Langbridge, M.A.
"Bear and Forbear." By Sarah Pitt.
"Foremost if I Can." By Helen Atteridge.

"Honour is my Guide." By Jeanie Hering (Mrs. Adams-Acton).
"Aim at a Sure End." By Emily Searchfield.
"He Conquers who Endures." By the Author of "May Cunningham's Trial," &c.

The "Log Cabin" Series. By EDWARD S. ELLIS. With Four Full-page Illustrations in each. Crown 8vo, cloth, 2s. 6d. each.

The Lost Trail. | Camp-Fire and Wigwam. | Footprints in the Forest.

Cassell's Picture Story Books. Each containing Sixty Pages of Pictures and Stories, &c. **6d.** each.

Little Talks.	Daisy's Story Book.	Auntie's Stories.
Bright Stars.	Dot's Story Book.	Birdie's Story Book.
Nursery Toys.	A Nest of Stories.	Little Chimes.
Pet's Posy.	Good-Night Stories.	A Sheaf of Tales.
Tiny Tales.	Chats for Small Chatterers.	Dewdrop Stories.

Cassell's Sixpenny Story Books. All Illustrated, and containing Interesting Stories by well-known writers.

The Smuggler's Cave.	The Boat Club.
Little Lizzie.	Little Pickles.
Little Bird, Life and Adventures of.	The Elchester College Boys.
Luke Barnicott.	My First Cruise.
	The Little Peacemaker.

The Delft Jug.

Cassell's Shilling Story Books. All Illustrated, and containing Interesting Stories.

Bunty and the Boys.	Surly Bob.
The Heir of Elmdale.	The Giant's Cradle.
The Mystery at Shoncliff School.	Shag and Doll.
Claimed at Last, and Roy's Reward.	Aunt Lucia's Locket.
Thorns and Tangles.	The Magic Mirror.
The Cuckoo in the Robin's Nest.	The Cost of Revenge.
John's Mistake.	Clever Frank.
The History of Five Little Pitchers.	Among the Redskins.
Diamonds in the Sand.	The Ferryman of Brill.
	Harry Maxwell.
	A Banished Monarch.
	Seventeen Cats.

Illustrated Books for the Little Ones. Containing interesting Stories. All Illustrated. **1s.** each.

Up and Down the Garden.	Those Golden Sands.
All Sorts of Adventures.	Little Mothers & their Children.
Our Sunday Stories.	Our Pretty Pets.
Our Holiday Hours.	Our Schoolday Hours.
Indoors and Out.	Creatures Tame.
Some Farm Friends.	Creatures Wild.

The World's Workers. A Series of New and Original Volumes. With Portraits printed on a tint as Frontispiece. **1s.** each.

The Earl of Shaftesbury. By Henry Frith.	Dr. Guthrie, Father Mathew, Elihu Burritt, George Livesey. By the Rev. J. W. Kirton.
Sarah Robinson, Agnes Weston, and Mrs. Meredith. By E. M. Tomkinson.	David Livingstone. By Robert Smiles.
Thomas A. Edison and Samuel F. B. Morse. By Dr. Denslow and J. Marsh Parker.	Sir Henry Havelock and Colin Campbell, Lord Clyde. By E. C. Phillips.
Mrs. Somerville and Mary Carpenter. By Phyllis Browne.	Abraham Lincoln. By Ernest Foster.
General Gordon. By the Rev. S. A. Swaine.	George Müller and Andrew Reed. By E. R. Pitman.
Charles Dickens. By his Eldest Daughter.	Richard Cobden. By R. Gowing.
Sir Titus Salt and George Moore. By J. Burnley.	Benjamin Franklin. By E. M. Tomkinson
Florence Nightingale, Catherine Marsh, Frances Ridley Havergal, Mrs. Ranyard ("L.N.R."). By Lizzie Alldridge.	Handel. By Eliza Clarke
	Turner the Artist. By the Rev. S A. Swaine.
	George and Robert Stephenson. By C. L. Matéaux.

Library of Wonders. Illustrated Gift-books for Boys. Paper, **1s.**; cloth, **1s. 6d.**

Wonders of Acoustics.	Wonders of Bodily Strength and Skill.
Wonderful Adventures.	Wonderful Escapes.
Wonders of Animal Instinct.	Wonders of Water.
Wonders of Architecture.	
Wonderful Balloon Ascents.	

Selections from Cassell & Company's Publications.

The "Proverbs" Series. Original Stories by Popular Authors, founded on and illustrating well-known Proverbs. With Four Illustrations in each Book, printed on a tint. 1s. 6d. each.

Fritters. By Sarah Pitt.
Trixy. By Maggie Symington.
The Two Hardcastles. By Madeline Bonavia Hunt.
Major Monk's Motto. By the Rev. F. Langbridge.

Tim Thomson's Trial. By George Weatherly.
Ursula's Stumbling-Block. By Julia Goddard.
Ruths Life-Work. By the Rev. Joseph Johnson.

Books for Children. In Illuminated boards, fully Illustrated.

Happy Go Lucky. 2s.
Daisy Blue Eyes. 2s.
Twilight Fancies. 2s. 6d.

Cheerful Clatter. 3s. 6d.
A Dozen and One. 5s.
Bible Talks. 5s.

Cassell's Eighteenpenny Story Books. Illustrated.

Wee Willie Winkie.
Ups and Downs of a Donkey's Life.
Three Wee Ulster Lassies.
Up the Ladder.
Dick's Hero: and other Stories.
The Chip Boy.
Raggles, Baggles, and the Emperor.
Roses from Thorns.

Faith's Father.
By Land and Sea.
The Young Berringtons.
Jeff and Leff.
Tom Morris's Error.
Worth more than Gold.
"Through Flood—Through Fire; and other Stories.
The Girl with the Golden Looks.
Stories of the Olden Time.

Sunday School Reward Books. By Popular Authors. With Four Original Illustrations in each. Cloth gilt, 1s. 6d. each.

Seeking a City.
Rhoda's Reward; or, "If Wishes were Horses."
Jack Marston's Anchor.
Frank's Life-Battle; or, The Three Friends.

Rags and Rainbows: A Story of Thanksgiving.
Uncle William's Charges; or, The Broken Trust.
Pretty Pink's Purpose; or, The Little Street Merchants.

Cassell's Two-Shilling Story Books. Illustrated.

Stories of the Tower.
Mr. Burke's Nieces.
May Cunningham's Trial.
The Top of the Ladder: How to Reach it.
Little Flotsam.
Madge and Her Friends.
The Children of the Court.
A Moonbeam Tangle.
Maid Marjory.
Peggy, and other Tales.

The Four Cats of the Tippertons.
Marion's Two Homes.
Little Folks' Sunday Book.
Two Fourpenny Bits.
Poor Nelly.
Tom Heriot.
Through Peril to Fortune.
Aunt Tabitha's Waifs.
In Mischief Again.
The Magic Flower Pot.
School Girls.

The "Great River" Series (uniform with the "Log Cabin" Series). By EDWARD S. ELLIS. Illustrated. Crown 8vo, cloth, bevelled boards, 2s. 6d. each.

Down the Mississippi. | Lost in the Wilds.
Up the Tapajos; or, Adventures in Brazil.

The "Boy Pioneer" Series. By EDWARD S. ELLIS. With Four Full-page Illustrations in each Book. Crown 8vo, cloth, 2s. 6d. each.

Ned in the Woods. A Tale of Early Days in the West.
Ned on the River. A Tale of Indian River Warfare.
Ned in the Block House. A Story of Pioneer Life in Kentucky.

The "World in Pictures." Illustrated throughout. 2s. 6d. each.

A Ramble Round France.
All the Russias.
Chats about Germany.
The Land of the Pyramids (Egypt).

The Eastern Wonderland (Japan).
Glimpses of South America.
Round Africa.
The Land of Temples (India).
The Isles of the Pacific.
Peeps into China.

Half-Crown Story Books.

Little Hinges.
Margaret's Enemy.
Pen's Perplexities.
Notable Shipwrecks.
Golden Days.
Wonders of Common Things.
Truth will Out.
At the South Pole.

Soldier and Patriot (George Washington).
Picture of School Life and Boyhood.
The Young Man in the Battle of Life. By the Rev. Dr Landels.
The True Glory of Woman. By the Rev. Dr. Landels.

Three and Sixpenny Library of Standard Tales, &c.
All Illustrated and bound in cloth gilt. Crown 8vo. 3s. 6d. each.

Jane Austen and her Works.
Mission Life in Greece and Palestine.
The Romance of Trade.
The Three Homes.
Deepdale Vicarage.
In Duty Bound.

The Half Sisters.
Peggy Oglivie's Inheritance.
The Family Honour.
Esther West.
Working to Win.
Krilof and his Fables. By W. R. S. Ralston, M.A.
Fairy Tales. By Prof. Morley.

The Home Chat Series.
All Illustrated throughout. Fcap. 4to. Boards, 3s. 6d. each. Cloth, gilt edges, 5s. each.

Half-Hours with Early Explorers.
Decisive Events in History.

Paws and Claws.
Home Chat.
Peeps Abroad for Folks at Home.
Around and About Old England.

Books for the Little Ones.

The Merry-go-Round Poems for Children. Illustrated 5s.
Rhymes for the Young Folk. By William Allingham. Beautifully Illustrated. 3s. 6d.
The Little Doings of some Little Folks. By Chatty Cheerful. Illustrated 5s.
The Sunday Scrap Book. With One Thousand Scripture Pictures. Boards, 5s ; cloth. 7s. 6d.
Daisy Dimple's Scrap Book. Containing about 1,000 Pictures. Boards, 5s.; cloth gilt, 7s. 6d.
The History Scrap Book. With nearly 1,000 Engravings. 5s.; cloth, 7s. 6d.
Little Folks' Picture Album. With 168 Large Pictures. 5s.
Little Folks' Picture Gallery. With 150 Illustrations. 5s.

The Old Fairy Tales. With Original Illustrations. Boards, 1s. cloth, 1s. 6d.
My Diary. With 12 Coloured Plates and 366 Woodcuts. 1s.
Sandford and Merton: In Words of One Syllable. Illustrated. 2s. 6d
The Story of Robin Hood. With Coloured Illustrations. 2s. 6d.
The Pilgrim's Progress. With Coloured Illustrations. 2s. 6d.
Wee Little Rhymes. 1s. 6d.
Little One's Welcome. 1s. 6d.
Little Gossips. 1s. 6d.
Ding Dong Bell. 1s. 6d.
Good Times. 1s. 6d.
Jolly Little Stories. 1s. 6d.
Daisy Dell's Stories. 1s. 6d.
Our Little Friends. 1s. 6d.
Little Toddlers. 1s. 6d.

Books for Boys.

The Black Arrow. A Tale of the Two Roses. By R L. Stevenson. 5s.
Commodore Junk. By G. Manville Fenn. 5s.
A Queer Race. By W. Westall. 5s.
Dead Man's Rock. A Romance. By Q 5s.
The Phantom City. By W. Westall 5s.
Captain Trafalgar: A Story of the Mexican Gulf. By Westall and Laurie. Illustrated. 5s.
Kidnapped. By R. L. Stevenson. Illustrated. 5s.

King Solomon's Mines. By H. Rider Haggard. Illustrated. 5s.
Treasure Island. By R. L. Stevenson. Illustrated. 5s.
Ships, Sailors, and the Sea. By R. J. Cornewall-Jones. Illustrated. 5s.
Modern Explorers. By Thomas Frost. Illustrated. 5s.
Famous Sailors of Former Times. By Clements Markham. Illustrated. 2s. 6d.
Wild Adventures in Wild Places. By Dr. Gordon Stables, R.N. Illustrated. 5s.
Jungle, Peak, and Plain. By Dr. Gordon Stables, R.N. Illustrated. 5s.

Cassell & Company's Complete Catalogue *will be sent post free on application to*

CASSELL & COMPANY, LIMITED, *Ludgate Hill, London.*

F347-11/9

Made in the USA
Columbia, SC
04 June 2017